JACK BEAL

JACK BEAL

ERIC SHANES

HUDSON HILLS PRESS

NEW YORK

For Jon and Holly Cree, with love

First Edition

Illustrations and compilation © 1993 by Jack Beal
Text © 1993 by Eric Shanes

All rights reserved under International and Pan-American
Copyright Conventions.

Published in the United States by Hudson Hills Press,
Inc., Suite 1308, 230 Fifth Avenue, New York, NY 10001-7704.

Distributed in the United States, its territories and posses-
sions, Canada, Mexico, and Central and South America
by National Book Network, Inc.

Distributed in the United Kingdom and Eire by Shaunagh
Heneage Distribution.

Distributed in Japan by Yohan (Western Publications
Distribution Agency).

Editor and Publisher: Paul Anbinder

Copy Editor: Edward Weisberger

Proofreader: Lydia Edwards

Indexer: Karla J. Knight

Designer: Binns & Lubin/Martin Lubin

Composition: U.S. Lithograph, typographers

Manufactured in Japan by Dai Nippon Printing Company

Library of Congress Cataloguing-in-Publication Data

Shanes, Eric.
Jack Beal / Eric Shanes. — 1st ed.
 p. cm.
ISBN 1-55595-039-6 :
1. Beal, Jack, 1931– —Criticism and interpretation.
I. Title.
ND237.B3S5 1993
759.13—dc20 92-32364
 CIP

CONTENTS

ILLUSTRATIONS

Works indicated with an asterisk (*) are reproduced in color.

JACK BEAL

JACK BEAL

Because of the greater catholicity of taste that has resulted from the demise of Modernist formalism, it has now become easier to apprehend that the history of Modernism embraces not only a progression of highly cerebral formalist investigations but also some less formalistically innovative but still aesthetically valid responses to the world. The subject of this book is an artist who certainly demonstrates the truth of that contention. Jack Beal first attained prominence in the early 1960s by renouncing abstract expressionism for representational painting, feeling that he was raising rather than lowering the stakes of his art by doing so. This radical change of direction (later paralleled by other American artists) was brought about by a profound dissatisfaction with the ability of abstract painting to deal with the specifics of lived experience, and equally because, in the absence of the compelling pictorial logic that is enforced by the employment of representational subject matter, the marshaling of abstract forms can easily seem like a wholly arbitrary process. Since the 1960s Beal has mined a rich vein of representationalism, which has usually demonstrated a fine sense of observation, an inventive painterliness, an acute responsiveness to shape and pattern, the ability to create dynamic compositional structures, and always the willingness to take artistic risks rather than languish in a single mode of picture making. Moreover, in his best works, Beal's pushing of representational forms to their interface with abstraction has been responsible for the creation of some of the most striking and unusual images of the period.

Jack Beal was born Walter Henry Beal, Jr., on 25 June 1931 in Richmond, Virginia, the son of Walter Henry Beal, the parts manager of an automobile dealership in the city, and Marion Watkins Beal (née Baker). The family lived first in Richmond and subsequently moved out to the nearby towns of Bon Air and Hallsboro where Beal's maternal family owned a mill that produced excelsior, a shredded pine material that was then widely employed for packing china. In Hallsboro the Beals lived with the future artist's aging and some-

what eccentric maternal grandmother, Lottie Watkins Baker, who resided in a huge, porticoed colonial mansion. Later on, in less happy phases of his childhood, Beal would remember this period of his life as particularly idyllic, and would always be aware thereafter "that there was a better way to live."*

In 1950 Beal graduated from high school. By now his father had died and his mother had moved down to Norfolk, Virginia, so it was to the Norfolk division of the College of William and Mary that Beal went to major in biology, with journalism as his minor (he had been sports editor of his high-school newspaper). Yet although he got good grades in these disciplines and was soon appointed sports editor of the college newspaper, by his sophomore year Beal had realized that he was not cut out to be either a biologist or a journalist, for "with biology I got thrown off the rails because of analytical chemistry, while with journalism I wrote the most clichéd sports stories you ever read in your life." Instead he dropped out and got a full-time job at the Norfolk Navy Yard, sorting electronic spare parts, and, in the spring of 1953, he enrolled for evening classes in art back at the College of William and Mary. Beal had always been interested in art and had drawn extensively as a child during periods when he had been bedridden due to ongoing ear infections. However, he had never thought seriously of art as a career, so it came as an enormous surprise to him when his teacher, Regina Bartley, saw promise in his work and encouraged him to go to art school, recommending that he apply to the School of the Art Institute of Chicago (SAIC), which he did in the summer of 1953 and was accepted.

In Chicago Beal got a part-time job with a Hearst newspaper, *The American*, obtained a room in the

YMCA, and enrolled at SAIC. At this time SAIC was an arena of experimentation and discovery, and the students were inspired by the successes of older Chicago artists as well as by recent graduates who had stayed in the city such as H. C. Westermann, Joseph Goto, Ellen Lanyon, Roland Ginzel, Nancy Spero, and Leon Golub. Similarly they felt challenged by the works of important painters like Richard Diebenkorn, Matta Echaurren, and several of the first-generation New York abstract expressionists shown by the dealer Allan Frumkin in his Superior Street gallery. As Beal fondly remembers:

It was a heady time—Sondra Freckelton, Red Grooms, Richard Estes, Claes Oldenburg, Richard Hunt, John Chamberlain, Norman Jaffe, Robert Indiana, Jay Milder, Lloyd Glasson, Peter Gourfain, Max Kozloff, Irving Petlin, and many other fired-up students were competing with, and supporting, one another. We were further challenged by having classes in the museum of the Art Institute, and we quickly understood that we could learn a great deal by seriously studying the masterpieces.

In this latter respect Beal was particularly struck by a small painting of bathers by Paul Cézanne, an Henri Matisse of a woman seated by a goldfish bowl, and another Matisse still-life, pictures that forcibly struck him as testifying to the fact that art could be "an enterprise of intelligence." As he would later state:

Those pictures showed the mind at work. Painting in and of itself was not really meaningful to me unless it could be taken as seriously as, say, medicine or some other scientific discipline. After all I had studied biology, and I wanted art to be as forceful, challenging, and intelligent an occupation as that. Until I saw pictures of real quality, I had tended to think of painting as just so much self-indulgent smearing around, but when I saw masterpieces by Cézanne, Matisse, and other painters of similar stature, I was bowled over; suddenly I realized the force of art.

At the Art Institute two teachers had the most profound effect on Beal's development. The first of these was Isobel Steele MacKinnon, who was responsible for a General Drawing class. A painter, MacKinnon had studied with Hans Hofmann in Europe between 1925 and 1929. Beal remembers her as a "Scottish Grande Dame" with an enormously authoritative personality, who offered cogent analyses of pictorial composition and structure, who projected belief in the creation of believable pictorial space, and, above all, who avowed artistic freedom, the necessity of the artist to emancipate herself or himself from constricting rules—even though simultaneously she emphasized that rules had to be mastered before they could be broken.

The second major influence at SAIC was an art-history teacher, Kathleen Blackshear, who taught the discipline "as art, rather than simply as art history, making us take art apart and look at its component pieces, so that we could arrive at an understanding of how it was put together in the first place." Thus every week she would have her students make six drawings or paintings that would analyze a work of art or architecture in terms of its linear and dimensional properties, its tonal values, colors, and textures. Additionally she would encourage the students to make works in the style of established masters, a process that was designed to make them regard art history as a living process and not just a theoretical one. The sum effect of her approach was to make her students *look* creatively, something that sadly has generally disappeared from the teaching of art history in art schools today.

And yet another influence—and in the long term obviously the most profound of all the influences upon Beal—made itself apparent well into his second year at SAIC, when he met and fell deeply in love with a first-year sculpture student, Sondra Freckelton, who hailed from Dearborn, Michigan, a suburb of Detroit. They were married in September 1955, when Freckelton

was providing her student income by working in a restaurant and Beal was earning his bread by working for a railway company; a wedding announcement in a Detroit newspaper stated that "Sandra [sic] May Freckelton, waitress, marries Walter Henry Beal, platformman."

Yet despite all the creative stimuli that SAIC offered, Beal never graduated from the school, dropping out after his third year; by 1956 he had had his fill of higher education and both he and Freckelton could see no point in obtaining a degree that would permit them to teach—they "didn't want to fall back on teaching as a way of supporting ourselves, because to be a good teacher you have to put as much energy into your teaching as you do into your art, and we figured that we only had a certain amount of creative energy in us and couldn't spread it too widely." In any case most of Beal's time had been spent drawing rather than painting at SAIC, and it was only the restraining influence of Freckelton that persuaded him to stay on for his third year. He could see that if he remained at SAIC for a fourth year, he might well end up painting in the manner of Pablo Picasso's Blue and Rose periods, which was the prevailing tendency among final-year Fellowship Competition students, and he did not wish to follow them in that. Instead, when Freckelton had finished her second year at SAIC in the summer of 1956, the Beals moved to New York, renting a loft at 178 Stanton Street for thirty-five dollars a month; by that Christmas they had been followed to the city by at least ten of their contemporaries at SAIC.

The Beals continued to live all the year round in New York City until 1962, when they began to move to various country cottages and farmhouses every summer. Although in later years they have spent most of the year in the country, they have maintained a studio-residence in Manhattan, in order to draw regularly on the intense atmosphere of the city. At first their

friends and neighbors included many abstract sculptors—Freckelton was to remain a sculptor until 1974—and later they became friendly with Red Grooms, Janet Fish, Marjorie Portnow, Robert Barnes, Alfred Leslie, and Chuck Close, among others. For the eight or so years after 1957 the Beals took various part-time jobs and worked at their respective disciplines on their own time, living first in a loft situated at 15 Bleecker Street and subsequently, after 1963, in another loft on Prince Street, where they were among the pioneers in the opening up of what is now called SoHo (at the time only two other artists were living there). Indeed, the Beals can claim responsibility for the legal opening up of SoHo: backed by the Artist's Tenants Association, between 1963 and 1970 they fought and eventually won the test case that enabled artists to live openly in the numerous factory buildings south of Houston Street.

For Beal in the latter half of the 1950s and the early 1960s, working at his art meant producing abstract expressionist pictures; at that time it was considered "the only valid way to paint." It had not been difficult for Beal to slide into such painting while a student in Chicago, quite simply because it was the prevailing tendency, and equally because the teaching of both MacKinnon and Blackshear had tended to emphasize identification with the abstract formal qualities of pictures. At this time he most strongly identified with the works of Arshile Gorky, whose drawings seemed to impart humanity and the reality of life itself in ways that were unparalleled by most artists of the day, and certainly not to Beal's eyes by other masters of the New York School such as Jackson Pollock, Mark Rothko, or Adolph Gottlieb.

Beal's need to cover large canvases and handle paint freely was boosted by the intense competitiveness of abstract painting in New York at the time. But even though he found it relatively easy to paint abstractly, and after some six years of doing so was invited to exhibit at Martha Jackson's gallery when he trundled several canvases uptown to a viewing by her in 1962, inwardly he knew that

these weren't my pictures; they were derivative, they were inspired by the work of my friends, they came out of Gorky and De Kooning. I went home from Martha Jackson's in a profound dilemma, for my paintings suddenly seemed to me to be just so much tinted fog—they were insubstantial; they had no structure or pictorial geometry; they were incredibly self-indulgent and just decorative. I asked myself how I could possibly show such works.

Because of this dilemma, eventually Beal refused the opportunity to show at the Martha Jackson Gallery. And that dilemma soon led to artistic blockage: faced with the lack of firm artistic direction that had caused his bewilderment in the first place, Beal took some of the many opportunities that presented themselves *not* to paint, even becoming for a short period a would-be (but unsuccessful) racing-car mechanic. Yet a way out of this unhappy predicament soon fortunately presented itself.

In the summer of 1962 the Beals moved for the season to a cottage on the Oswegatchie River at Black Lake, in upstate New York. As the painter recalls:

I wanted to give Art one more try; I had this vague notion that I wanted to get more natural form and color back into my paintings, although at that time I had no notion at all of becoming a representational painter. But up at Black Lake I found myself painting from nature and loving it—I fell in love with painting all over again. I painted like fury that summer, and when I took the resulting canvases back to New York, I still felt good about them.

Oswegatchie River, 1962
oil on canvas
70 × 65 in.
Frumkin/Adams Gallery, New York

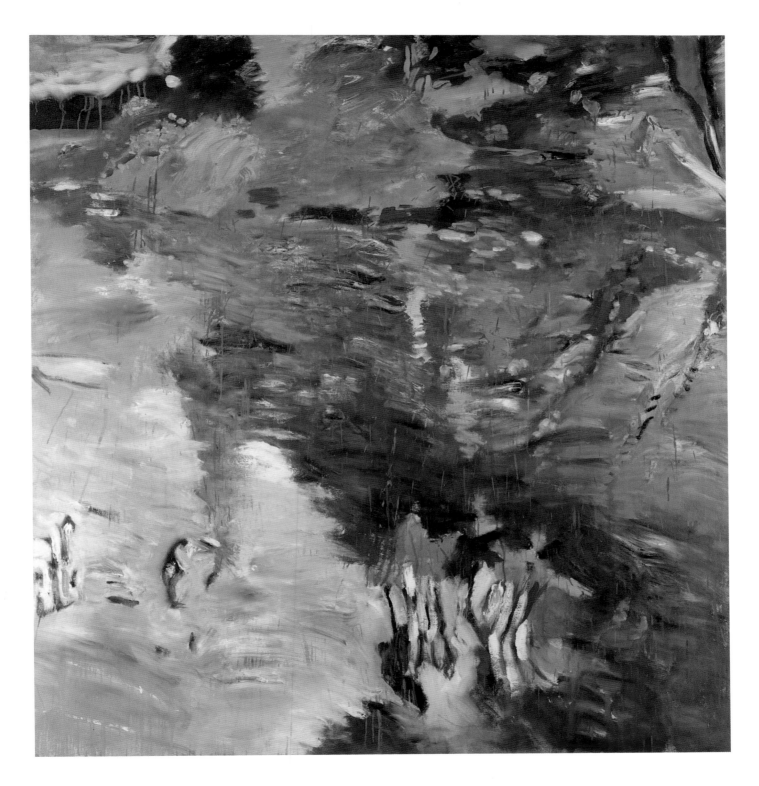

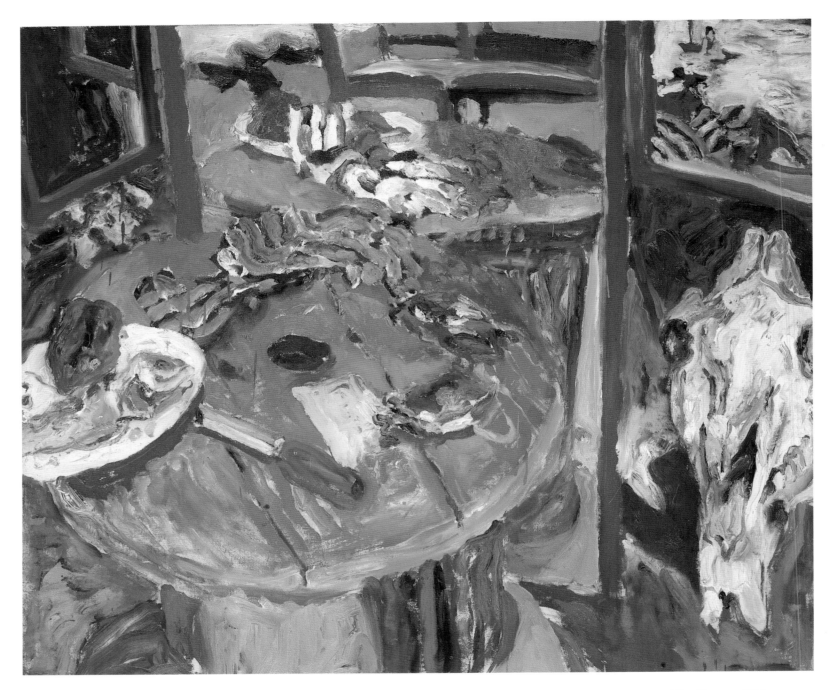

**Still-Life with Vanity
Mirror, 1963**
oil on canvas
42 × 49½ in.
Frumkin/Adams Gallery, New York

The Pump, 1963
oil on canvas
52 × 57 in.
Collection the artist

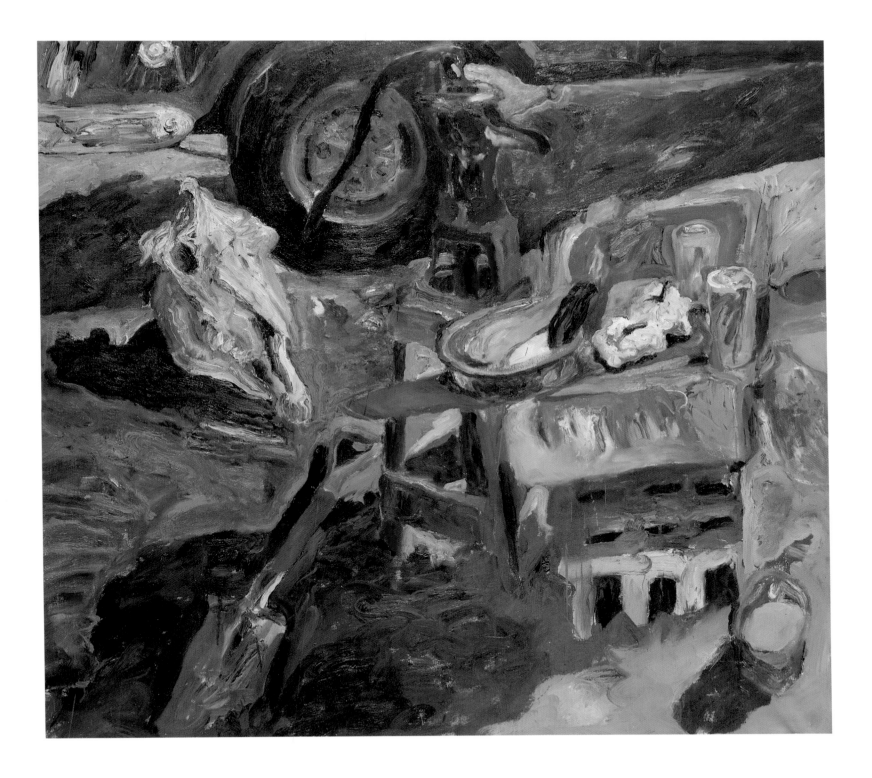

The pictures of this period marry expressionistic freedom of paint handling with a brutally simplified representationalism, as though the artist had come under the influence of Chaim Soutine: the intensity of emotion and technical approach produced a Soutine-like stylistic formation. But clearly the motivation supplied by direct contact with nature gave Beal more sense of direction as an artist, and this was something he maintained throughout the following year. Armed with such confidence, Beal also felt more positive about publicly showing his work, and indeed was very gratified when Allan Frumkin, who had galleries in Chicago and New York, offered him half of a two-person exhibition in the Chicago gallery in the autumn of 1963. During the interim Frumkin also sold some of Beal's pictures through the Chicago gallery, which further boosted the artist's self-confidence.

Given the positive artistic effects of the Black Lake trip, in the summer of 1963 the Beals rented a log cabin for the season on Cabin John's Creek, near Elkton, Maryland. They had been promised money sent in installments by the purchasers of some pictures, but it never arrived, so after covering the rent with what little money they did have, the Beals were forced to live off the land. They ate squirrel meat, catfish, perch, and blue crabs they caught themselves; mushrooms, berries, and apples picked in the wild; and blackberry wine made by wringing the berries through a T-shirt and fermenting the juice in a receptacle placed under the cabin. Yet Beal's creative drive was at last fully liberated in Maryland, as he pushed on with his artistic breakthrough of the year before and made expressionistic paintings that, in their roughness, related directly to the rough life-style that he and his wife were then living. These were paintings in which his desire to blur the distinctions between life and art was fully realized.

Back in New York that winter Beal painted in his spare time when not earning his keep by undertaking carpentry, plumbing, and electrical work. One of his jobs was to have a direct bearing upon his existence as an artist, for he had a confrontation over payment with a leading artist who was one of his clients and decided

I never wanted to be dumped on like that ever again. In order to avoid such treatment I resolved to use my art to make it impossible. So I told Sondra and a couple of other close friends that I was going to make big, important paintings that people couldn't ignore. They condescendingly said, "Sure, Jack, we believe you—go ahead," but they didn't take me too seriously. But I knew I had no other choice.

There were several painters whose works showed me the way. Jim McGarrell, Paul Georges, and Fairfield Porter were making ambitious pictures and relegitimizing representation in the process, as were the Pop artists, who exploited recognizable imagery from advertising and popular culture. It was about this time that the critic Clement Greenberg told Porter and Willem de Kooning that artists could no longer paint human beings because of the advent of hard-edge colorfield painting. Both painters took this as a challenge and went on to make remarkable figurative works. McGarrell and Georges especially accepted no limitations on their art: they made fantastic narrative pictures from all sorts of sources and attracted many followers. Their pictorial ambitions were huge, and I learned important lessons from them.

Once again a summer spent painting away from New York City helped Beal to clarify his artistic intentions, as well as his cultural ambitions. In

The Saw, 1964
oil on canvas
80 × 75 in.
Mellon Bank Corporation, Pittsburgh, Pennsylvania

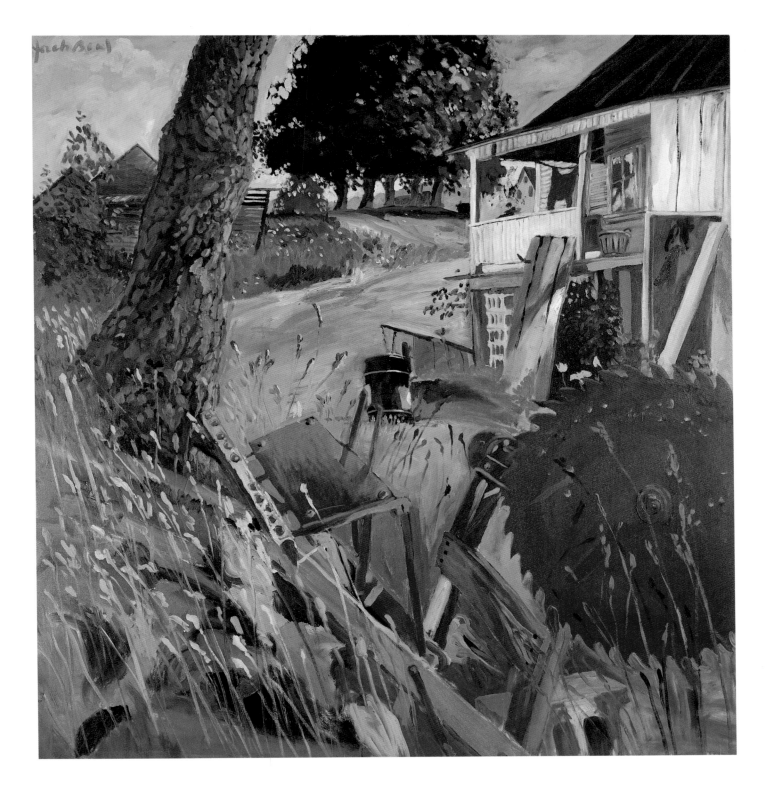

19

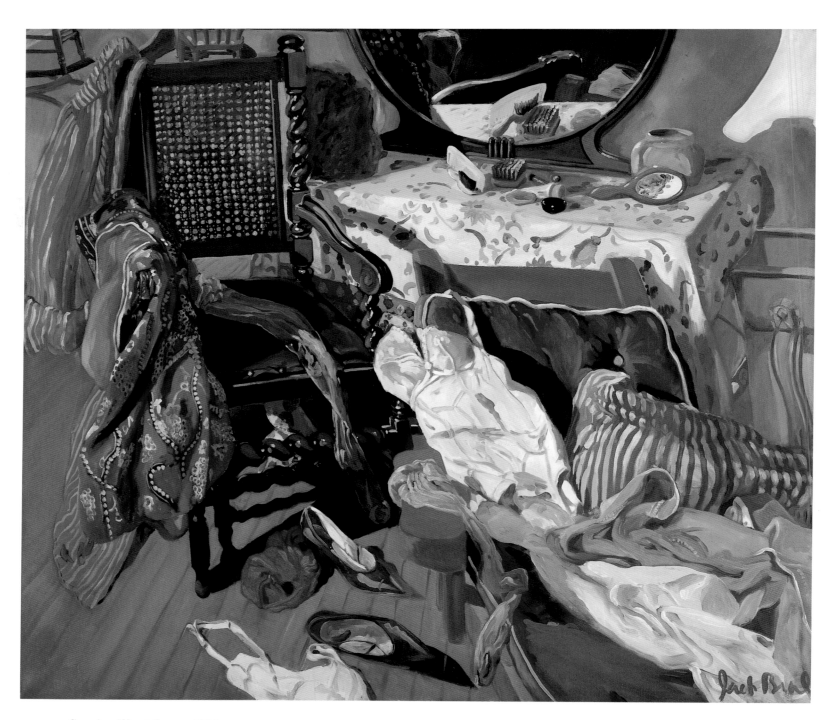

Sondra Went Away, 1964
oil on canvas
56½ × 64 in.
Mr. and Mrs. Stanley M. Freehling

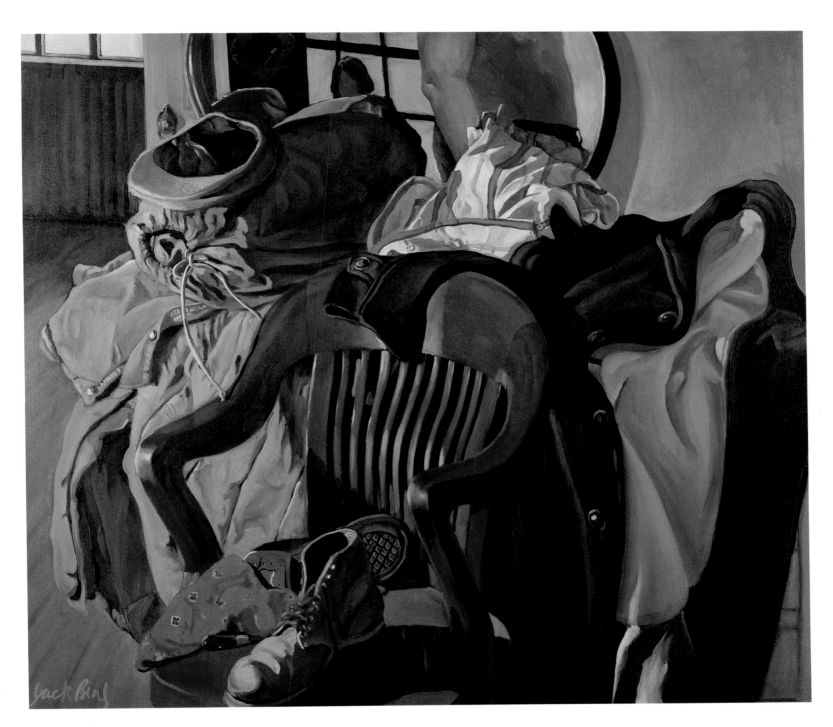

Jack's Equipment, 1964
oil on canvas
48 × 54 in.
Jerry and Elise Pustilnik

1964 the Beals rented a farmhouse at Wyalusing, Pennsylvania, and it was there that the painter created what he regards as his first important picture, *The Saw*, investing "every particle of energy and emotion I had into it." In *The Saw* the artist clearly reveled in the weather-beaten textures of the dilapidated farmhouse and the debris strewn around it, while enforcing tension through varieties of pictorial emphasis, as with the contrast of the stalks on the left and the empty area in the center. At the same time the influence of the spatial structuralism taught by MacKinnon can be detected in the predominant linear stress of the work, whereby the eye is directed into the pictorial space by means of the diagonals leading up from the bottom center.

When Frumkin saw the work back in New York later that year, he realized that the artist had reached a turning point and told him that if he could make half a dozen further pictures of the same strength, he would give Beal a solo show in New York. On 25 January 1965, less than five months later, that show opened in the Frumkin Gallery on 57th Street, and all the paintings were sold. A second exhibition held in the same venue in November 1965 featured a large batch of paintings made during a return visit to Black Lake during the intervening summer, and it sold out as well. These two sellouts had important ramifications. First, they meant that Beal could devote himself to painting full time, a liberation that was reflected in the artistic output that ensued. Second, his works entered many important private and public collections. And third, and perhaps most important of all, the success justified Frumkin's belief in Beal, a belief that has naturally proven crucial to the painter: "My relationship with Allan Frumkin, my dealer for twenty-seven years, has been vital to my development. The encouragement and support of a dealer, coupled with success in placing pictures, give an artist the confidence to make bold and daring pictures."

What increasingly characterizes the pictures of this period is the degree to which Beal was bringing a more accurate descriptiveness to his representation—eschewing the somewhat expressionistic depiction of forms and subjective emotional intensity of his earlier painting—coupled with an exploration of the extreme contrasts and abstract formations that could be created by juxtaposing dissimilar textures and patternings. Thus, to take a typical example, in *Still-Life with Snow Shovel* of 1965 the objects represented all enjoy a high degree of informational definition that is balanced by the degree to which Beal emphasized the inherent abstract patterning of those objects, both in terms of overall form and in terms of the light and shade distributed across them or the patterns imprinted upon them. Through the next few years Beal's pleasure in patterning and the ways that it could offset the distinctions of form would occasionally be advanced by the use of cardboard masks and cutouts placed near a light source so as to intensify the breakup of light and shade. Throughout the latter half of the 1960s such experiments with appearances would become a great source of strength in Beal's art, leading him to make complex, spatially ambiguous, and richly colored works that exist at the very interface between representation and abstraction.

That interface was not in any way compromised by Beal's newfound and increasing desire from the mid-1960s onward "to make the world inside the canvas nearly as real as the world beyond it." Such a dedication to the fictive reality of painting would stay with Beal thereafter and even increase in time. As Beal comments:

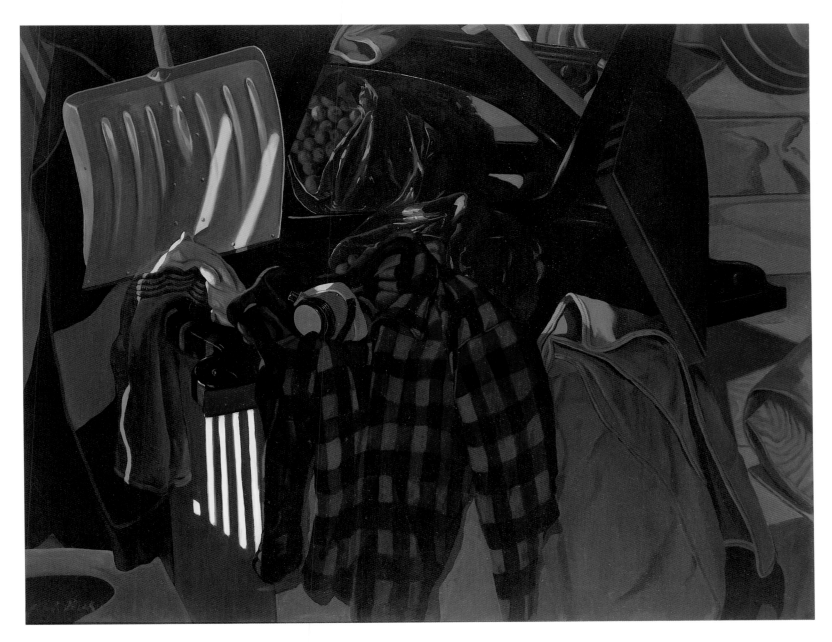

Still-Life with Snow Shovel, 1965

oil on canvas

48 × 60 in.

The Fine Arts Center/Cheekwood, Nashville, Tennessee
—Gift of the American Academy and Institute of Arts
and Letters—Hassam and Speicher Purchase Fund

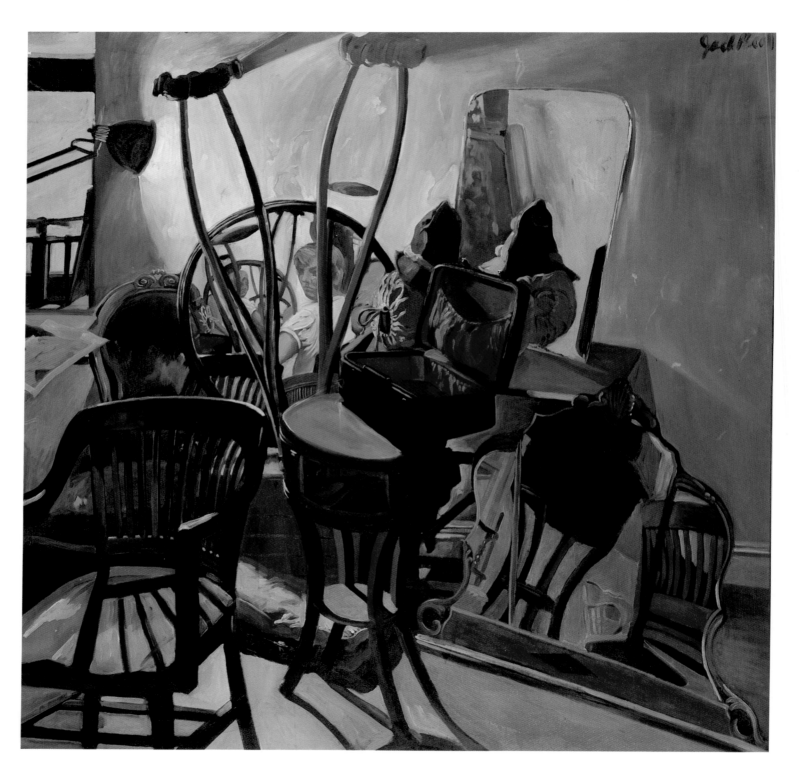

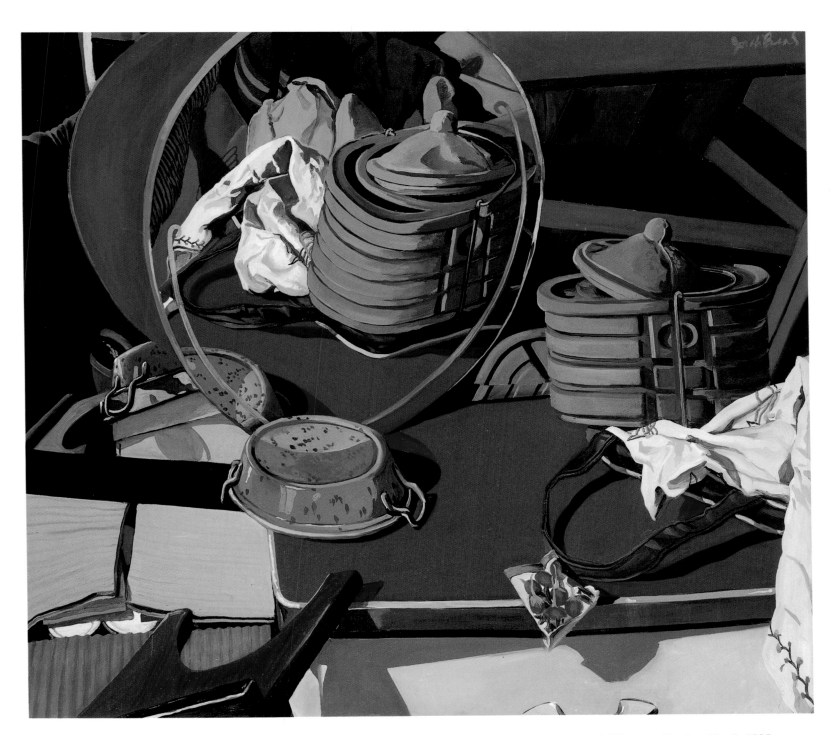

Random Walk, 1964
oil on canvas
79½ × 80 in.
Frumkin/Adams Gallery, New York

Still-Life with Minnow Bucket No. 2, 1965
oil on canvas
38 × 42 in.
Frumkin/Adams Gallery, New York

My attempts to enhance the connections between art and life (and between the picture and the viewer) brought about several unexpected changes in my work. Thus the paint handling was clarified; the compositions became more dynamic and invitational to the viewer; and the narrative aim of the pictures was intensified.

Regarding the paint handling: in 1963 I made a portrait of Ivan Mischo, a fine painter and a fishing buddy. It was a good likeness, but when I looked back over the work at a later date, I realized that I had been overindulgent and even egomaniacal with the paint application: Ivan's flesh looked as though it had been flayed. I began to understand that if I wanted viewers to believe in the pictures and hoped to do justice and homage to my sitters, then I had to paint them with faithful attention to reality and without "art marks."

The compositions changed because I wanted to open up the space beyond the picture surface— to try to make the pictorial space as believable as real space. Using all the lessons of Isobel Mac-Kinnon, I began stressing diagonals as lines of entry and exit, as well as using empty chairs and other foreground objects as "welcome mats," and linear fractures and convolutions as a means of drawing the viewers into the image and pressing the subjects out into the world.

As for narrative: I determined to tackle it head on, even though I knew this was an unfashionable stance and one likely to provoke negative criticism. It was a challenge—another way of raising the stakes—of regaining some territory that had once been a central motivation of art but had recently been declared taboo. I was not about to allow pseudomodernist academicism to limit my options or impinge on my freedom.

And in addition to these developments Beal married a certain measure of idealism to his representationalism. Around the mid-1960s he was particularly struck by seeing the superb *Breakfast Room* by Pierre Bonnard in the Museum of Modern Art, New York:

In the most naive, unconscious way I heard myself saying to myself, "Gee, I'd love to live there." Every once in a while I will actually take note of something I say to myself, and so I responded by thinking, "What a great motivation for making pictures—to make your viewer say, 'Gee, I'd love to live there.'" And I thought that if I can compel such a desire in my audience, then I can make my paintings more important and draw the very best out of myself.

Such a motivation led Beal consciously to attempt making pictorial worlds that are as attractive as the real world, if not more so. In the longer term this idealism would lead Beal back to the natural offshoot of artistic idealism, namely moralism, the humanist desire to differentiate good and evil in the world and to state that identification, however baldly, through art. A natural vehicle for moralism is the use of mythological subject matter, and Beal availed himself of that vehicle in what was his first major treatment of the reclining nude, *Danaë I* of 1965, which was painted as a way of signaling his identification with The Great Tradition of Western Painting (as typically represented by Mabuse, Titian, Tintoretto, Correggio, and Rembrandt, who also tackled the subject of Danaë). Beal regards this work, along with *Danaë II* of 1972, as one of his most successful statements, a picture into which he poured himself most generously and from which he obtained a great deal of creative satisfaction.

In Greek mythology Danaë, the daughter of Acrisius, the king of Argos, was shut away in a tower to prevent her from meeting any suitors and thus

Danaë I, 1965
oil on canvas
66 × 72 in.
Dr. Marcella Halpert

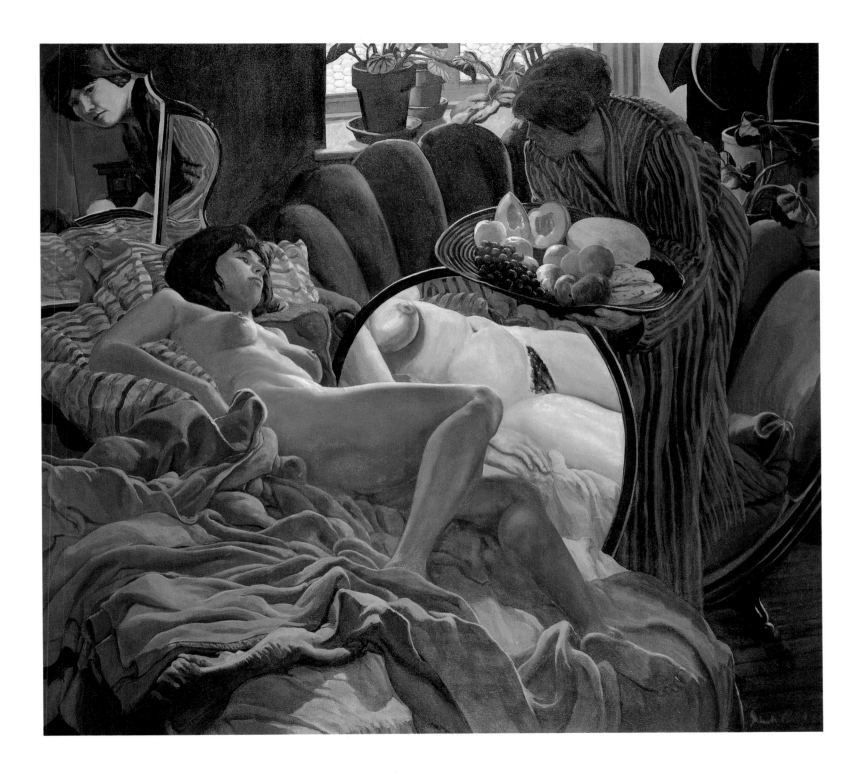

ultimately bearing the son who, it was predicted, would be responsible for the death of her father. But Zeus obtained entry to the tower by changing himself into a shower of golden rain and then had his way with Danaë; the offspring of their union was Perseus, who would later accidentally kill his grandfather with a discus. In traditional representations of the subject Danaë is depicted in the nude, lying recumbent with the gold falling around her and a maidservant holding out her apron to catch it (although Mabuse represented Zeus merely as a cascade of light rather than as a shower of gold, an approach that Beal knew and also adopted).

Beal exhibited *Danaë I* in his second solo show in 1965, and in the work he combined his growing responsiveness to human form with his feeling for abstract patterning and rich colors. In it he also manipulated illusion and reality (as with the interplay of real and mirrored forms in the center of the image and at the top left), while simultaneously raising questions of identity—the nude is Freckelton but so, quite clearly, is the maidservant, judging by her face in the mirror at the top left; Beal admits to dealing here with the fact of modern life that "every woman is her own maidservant." Yet the work not only portrays the realities of flesh, fruit, and fabrics but equally celebrates them. Although Beal has provided us with no stereotypical visual clues that we are looking at a mythological subject, clearly there exists a dramatic tension between the protagonists, and the sexuality implicit in the mythological subject is subtly apparent. This is heightened in turn by the immediate conjunction of sexual attributes and abundant fruits, the centrality and tonal dominance of the reflected part of the nude torso, and the apparent disturbance of the bedding. The coherent linear structure of the image enforces a new sense of drama in Beal's work, while the light works

efficiently as a means of alluding to the presence of Zeus in the scene (and it is worth noting that the light falling upon the nude appears at its most intense in her reflection in the circular mirror in front of her, as though the god were still in her immediate vicinity but located in some illusory realm). As a result of all these factors the picture works on a number of levels: as a complex nude and still-life image; as a statement of implied sexual relations; as a Realist representation of contemporary, pampered ease; and as the secular reworking of an ancient myth transferred to modern Manhattan.

Freckelton was her husband's most frequent model at this time (and the only nude he employed), quite simply because she was so readily available to pose and so helpful: she would come down from her studio exhausted from her own work as a sculptor and happily lie or sit around relaxing at night while she was painted. One of the most successful works painted at this time is *Sondra in Three Vanity Mirrors* of 1966, which—with its frequent shifts of reality versus illusion and its elisions, shadowings, and maskings of the face—projects disturbing questions about the nature of identity. Another statement about personality and identity is *The Roof* of 1964–65, the large canvas that dominated the artist's first solo show. Here we see Freckelton twice, sitting and lying somewhat surrealistically amid the rooftop litter of contemporary New York. The fact that the artist had frequently to run up two flights of stairs to the roof in order to obtain details of the setting while he was painting the picture during December 1964 and January 1965, may perhaps account for a slight spatial disjunction in the work. As a representational

Sondra in Three Vanity Mirrors, 1966
oil on canvas
58 × 64 in.
Ruth & Jane Root

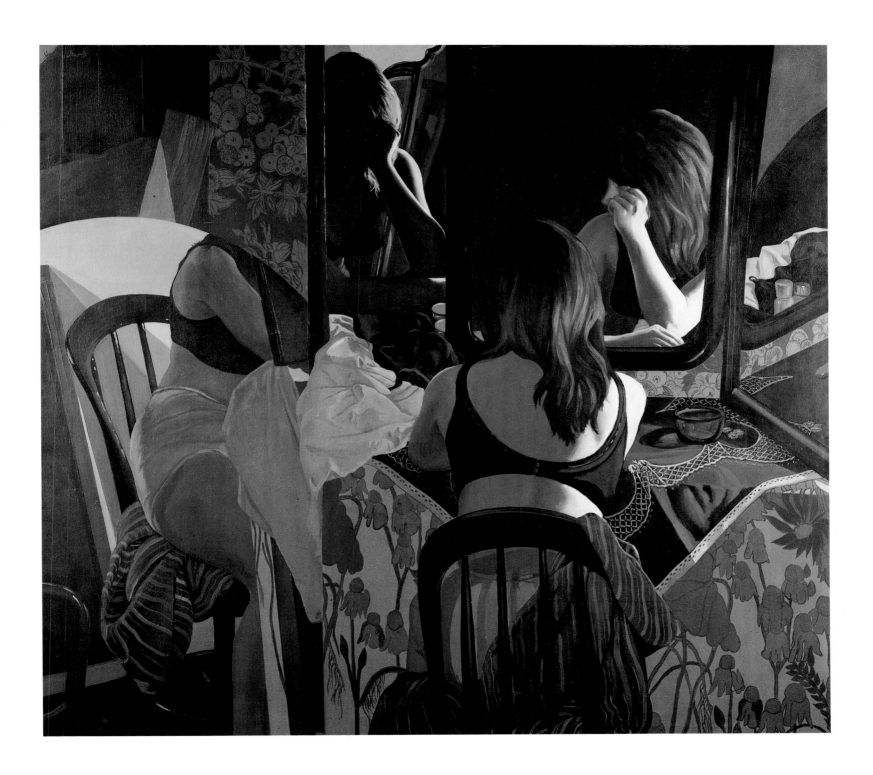

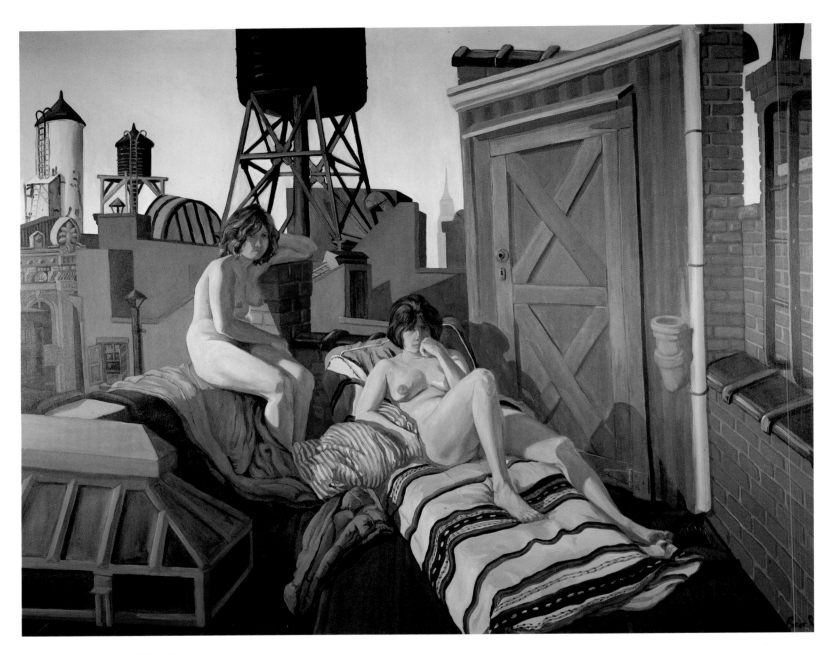

The Roof, 1964–65
oil on canvas
96 × 120 in.
Daniel Varenne, Geneva

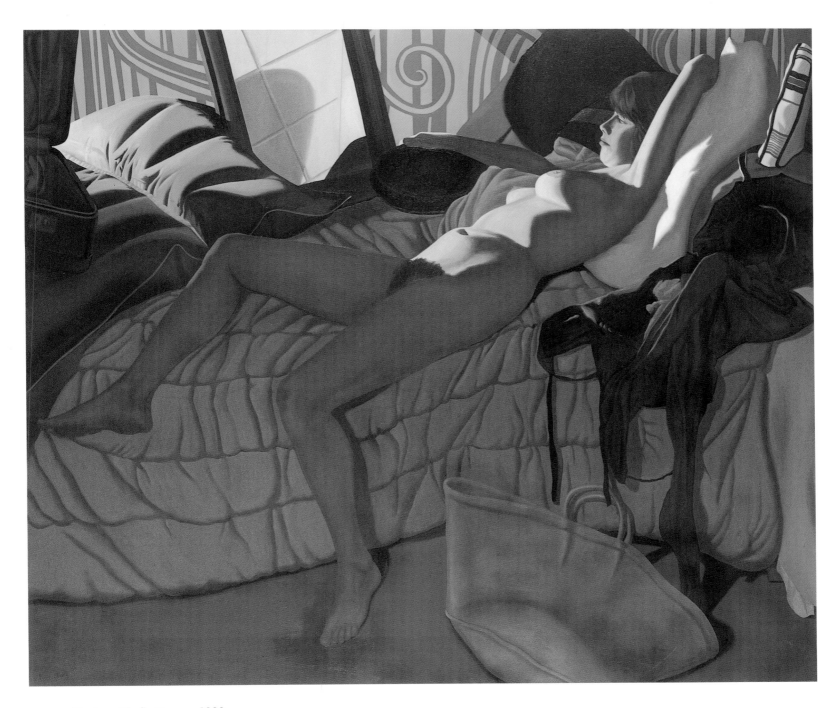

Nude with Suitcase, 1966
oil on canvas
$66\frac{1}{4} \times 72$ in.
Daniel M. Honigman

painter Beal is always at his best when he has his entire subject set out before him, and he explains his occasional lapses as being mainly due to the fact that

most of the Realists of my generation were not trained to work representationally. In my own case I had only one semester of "straight" figure drawing in art school, and no discussion of anatomy whatsoever. All my training centered on aesthetics and Modernist formalism. Important as those subjects are, my training still left gaps in my knowledge, which I had to fill myself by diligent study of masterworks and through hard work.

Yet Beal's success in dealing with the nude is very apparent in another picture of 1965, the *Striped Nude*. This work had its origins in a study that the artist had earlier made of cartography and the way that nonpainters, such as mapmakers and electricians, represent the third dimension on a flat surface; from that study came the desire "to make a topographical map of Sondra." But the painting grew into something much more than simply a map in which shadows define contours. Instead Beal created a haunting sense of solitude, if not entrapment, as the bars of shadow fall across the nude and seem to confine it. A sense of disturbance is suggested by the bare floorboards, empty basket, cast-off clothing, and the general feeling of dishevelment in the setting—as though the woman were reclining in a derelict room—for one does not usually witness nude women lying around dreamily in such somber and bleak surroundings. Ultimately that context serves to project the apparent inward sadness of the woman herself.

Throughout the latter half of the 1960s Beal went on painting the nude as well as still-life pictures, in all of which his interest in exploring the intrinsic abstract values of forms coexisted easily with the desire to make the painted reality of the subject as convincing as possible. Nowhere was Beal happier than in setting some inanimate objects or the human form amid complex patterns and shapes, and sometimes elaborating that complexity—as in *Nude with Patterned Panel* of 1966—so that we have to work hard to recognize exactly what we are seeing. Yet these complex surrounds are not mere decoration; instead they work as vehicles for the expression of feelings, adding to the mood engendered by the central subject. And in works such as *Danaë I* and *The Roof*, let alone the Boucher-like *Sondra with Shell Sofa* of 1967 (where the shapes and red color of the sofa act as metaphors for the sexuality and sexual parts of the nude), Beal unashamedly paid homage to the physical aspects of human relationships. Moreover, through this celebration of the physical he was simultaneously paying homage to his wife, "to the best and most beautiful person I know, and sharing my love for her."

Beal was very trusting as to how his artistic celebration of his wife's sexuality would be interpreted by others, and an unfortunate experience in the mid-1960s demonstrated to him how easily that trust could be compromised. One day he was moving one of the life-size pictures of a nude Freckelton to a waiting truck when three passing day laborers walked up to the canvas and began kissing the nude image and making crude fondling gestures. Although Beal quickly drove off, the experience brought home to him just how sexually "available" he had made Freckelton through his work:

Striped Nude, 1965
oil on canvas
66 × 72 in.
Buchbinder Family Collection

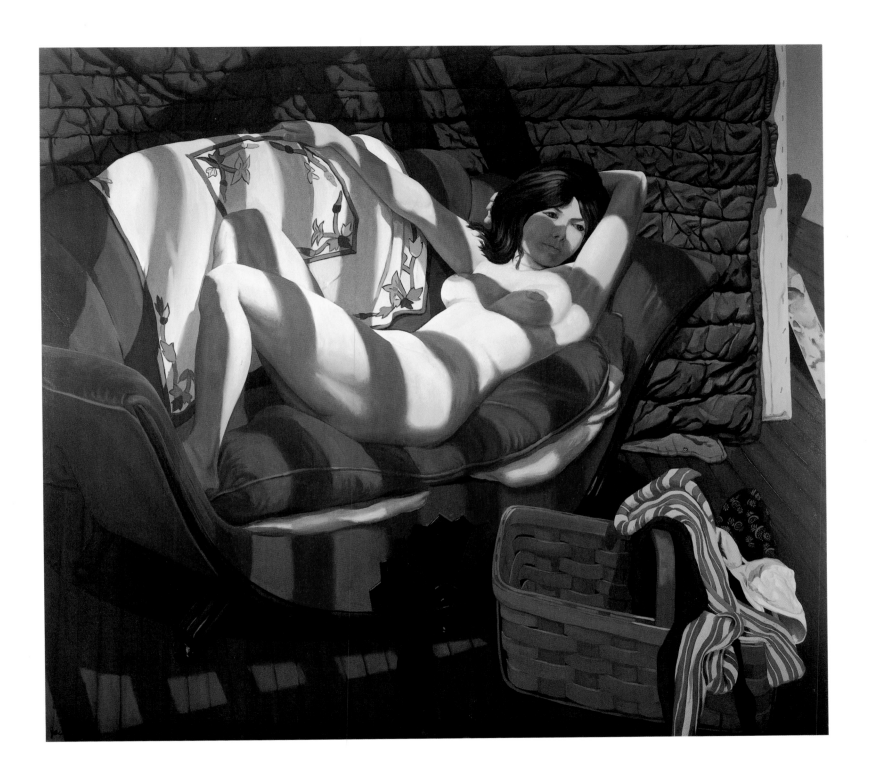

Nude with Patterned Panel, 1966
oil on canvas
70 × 76 in.
The John and Mable Ringling Museum of Art, Sarasota, Florida

Sondra with Shell Sofa, 1967
oil on canvas
72 × 78 in.
Malcolm Holzman

This incident shook me—I was enraged at the assault on the picture, but at the same time I was thrilled that the realism of the painting had provoked the attack. I was uncomfortable about this dualism, but it taught me that I could achieve a higher degree of reality if I committed myself totally to the world of the picture as I had done with the paintings of Sondra. I understood the Pygmalion and Galatea story fully for the first time, and I have since used every device at my command to heighten my commitment to the characters in my work—I talk to them; I have fantasies about living in the paintings with them and about the painted figures emerging from the canvas. This was such a natural progression, and it happened so quickly, that I barely questioned the rationality of it all.

On reflection Beal realized that he had no option to using his wife as a nude model, for other women just did not inspire him in the same way, and in any case the readiness of Freckelton to pose was not matched by other models. In time the contradiction between the need to use his wife as a model and the disinclination to make her available on canvas would act as an impairment to Beal's treatments of the female nude, and would be responsible for the fact that after his unfortunate experience with the passing workmen, the painter frequently employed masking in his imagery to either hide the nude or at least to act as a barrier to our imaginary access to it. Such reticence can easily be witnessed in many paintings of the middle to late 1960s, although not necessarily to detrimental effect. For example, one of Beal's finest paintings of the period—indeed one of the finest of all his paintings—is the superbly complex *Nude with Patterned Panel*, where the total masking of the torso and face of the model is effected by means of a panel that runs counter to the set of diagonals that cut their way upward toward the top left from the chair at the bottom right,

and where the range and balance of colors is extraordinarily fresh and rich. Here the obscuring of the figure appears to have spurred Beal's imagination rather than fettered it. But masking was also accomplished by less visually stimulating means in other pictures of this period, as in *Sondra in Tights with Air Mattress* of 1967, where the model is partially clothed, or *Nude on Chaise* of 1968, where she has her back to us and is isolated in her own space by the massiveness of the chaise and the large area of floor in the foreground.

In *Nude on Chaise* we can also witness the increasing geometricization that became a marked feature of Beal's work in the late 1960s, a feature that reached its apogee in the series of nine full-scale paintings of tables that he made in 1969. The idea of painting a table had first come to him in a dream, although in any event his preoccupation with the subject was the logical extension of his responsiveness to the abstract forms he had already been dealing with. The artist soon became fixated with exploring every visual aspect of "the dumbest, plainest object we had in our inventory," although today he thinks that the exercise was a wasted one as he "explored things that were hardly worth exploring." The laboriousness of painting these pictures—for which Beal refused to use masking tape to obtain his straight edges—was greatly ameliorated by the help of an apprentice. Beal now dislikes the abstractness of the table paintings, and feels that with them he overshot the mark he had earlier aimed for in effecting a perfect balance between modeled forms, such as the nude or still-life

Sondra in Tights with Air Mattress, 1967
oil on canvas
68 × 75 in.
National Museum of American Art, Washington, D.C.

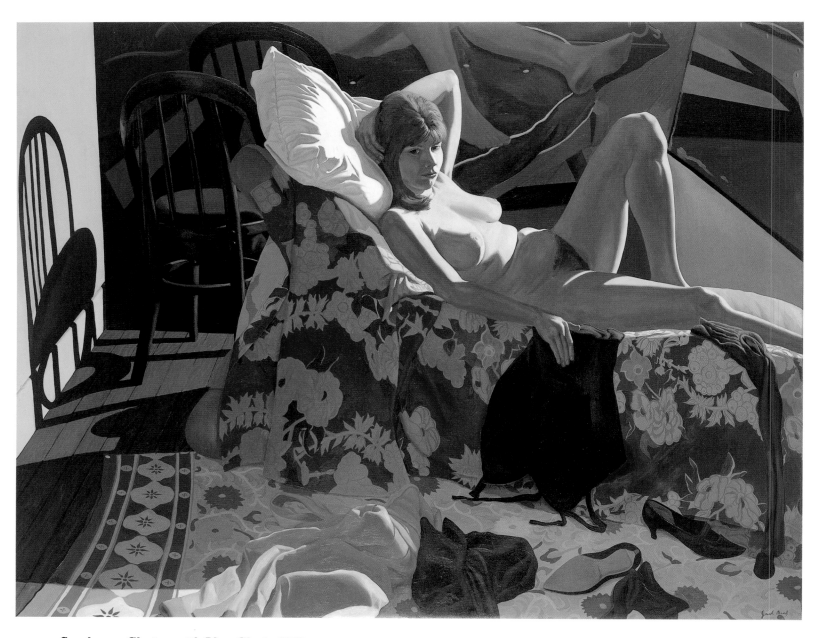

Sondra on Chaise with Blue Chair, 1966
oil on canvas
62 × 80 in.
Shelby White and Leon Levy

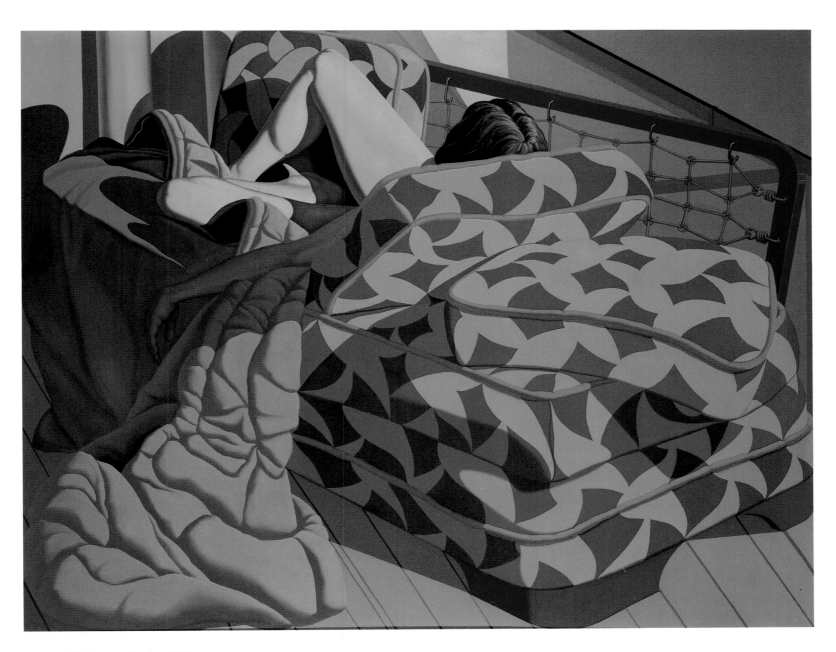

Madison Nude, 1967
oil on canvas
60 × 76 in.
Robert Frumkin

objects, and the flat abstract patternings of their surroundings. Although the tendency toward abstractness and surface flatness was very much in the air during the late 1960s, in retrospect Beal regrets having been diverted by it from his innate humanism, love of elaborate, sensuous forms, and need to create an idealized reality in his art.

It was while exhibiting the series of table pictures at the Frumkin Gallery in 1969 that Jack Beal was forcefully led back to his truer self by meeting a couple of Realist painters who had seen the show and were prompted to express their dismay at where he was heading:

Alfred Leslie and Sidney Tillim almost mugged me, pushing me into a doorway on upper Madison Avenue and berating me for betraying Realism and betraying myself, for moving away from "the true path." It was one of the finest things that anyone ever did for me, for not only was their advice very pertinent, but it showed that they really cared for me—Realist painters rarely even talk to one another—and I was deeply touched.

Armed with this insight, Beal began to pull himself back from abstraction by spending the latter half of 1969 and early 1970 working on an enormous canvas (7 feet by 18 feet) entitled *Peace*, which shows a distant nude reclining in a barn and looking out over a hot, bare landscape whose contours are delineated by lines of stacked grain. Beal painted this picture at the height of the Vietnam War—against which he and Sondra had been early protesters —and attempted to imbue the work with a sense of both solitude and disquiet, employing the hot, flowing landscape as a metaphor for the turbulent world beyond his studio. Soon after painting *Peace* he also painted two pictures of Freckelton seated by a circular table, as well as creating masses of

pastel and charcoal drawings of landscape and still-life subjects. A subsequent month-long teaching residency at San Diego State College in the fall of 1970, and the inspiring drives across America to get there and back, further aided Beal in rejecting the abstract tendencies of the table series. However, for a time he continued the use of the flat, hot colors that is found in the table pictures and apparent in *Peace*, as well as in some subsequent pictures of the nude.

Over the next couple of years Beal reestablished the balance between abstraction and figuration in his art, as can be seen in a number of works such as the painting entitled *Drawing* of 1971; *Portrait of the Doyles* of 1971 (now in the collection of the National Gallery of Art in Washington D.C.), where the artist inventively employed diagonals to unify the composition and lead us into the pictorial space; and in the richly colored, seductive portrait, *Sondra on Chaise* of 1972. In this last work the chair in the foreground unifies the composition, serves as a barrier between the viewer and the nude, and pulls the eye into both the center of the picture and its imaginary space. Above all, however, the revitalization of Beal's art can be witnessed in *Danaë II*, dating from 1972, where once more we witness the use of a favorite Beal device, the diagonal stress that leads us into the picture. As in *Danaë I* the two women are again quite evidently based upon a single model, namely Sondra Freckelton Beal, but their relationship appears more disturbed than it does in the earlier picture, as though something painful has occurred in the interim—perhaps we are now looking at the scene *after* Zeus has had his way with

Drawing, 1971
oil on canvas
60 × 68 in.
Galerie Claude Bernard, Paris

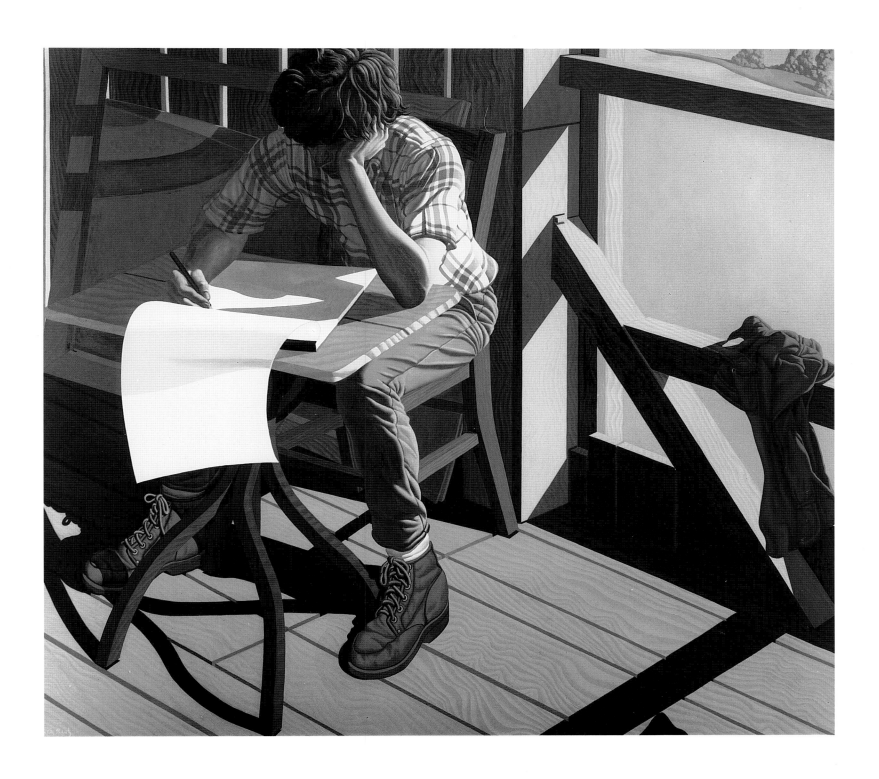

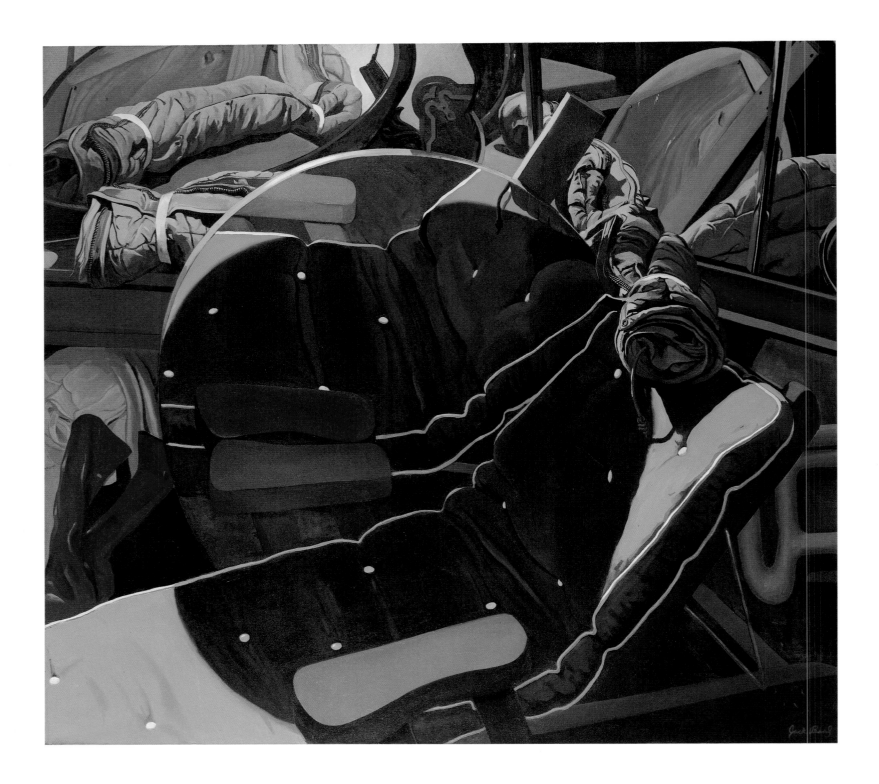

The Large Chaise, 1965
oil on canvas
72 × 78 in.
Exxon Corporation

Portrait of the Doyles, 1971
oil on canvas
78 × 58 in.
The National Gallery of Art,
Washington—Gift of Evelyn and
Leonard Lauder

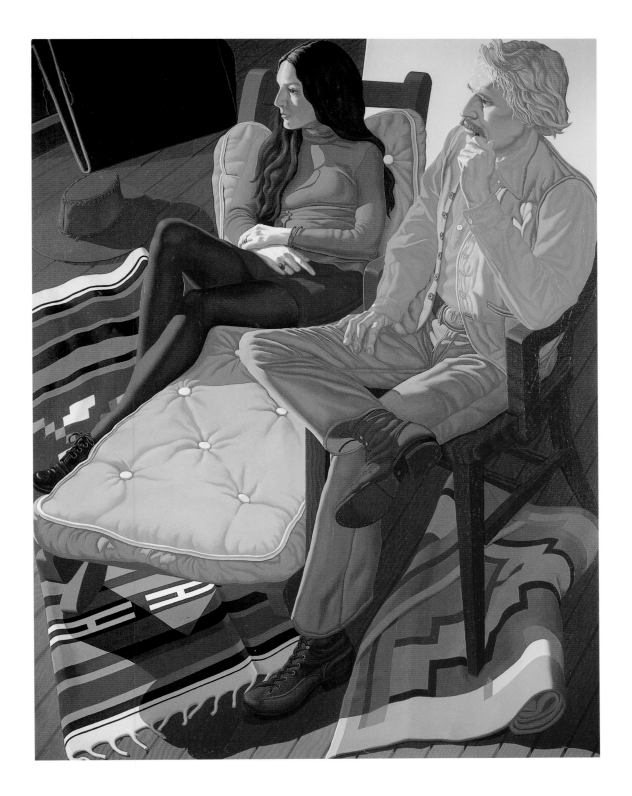

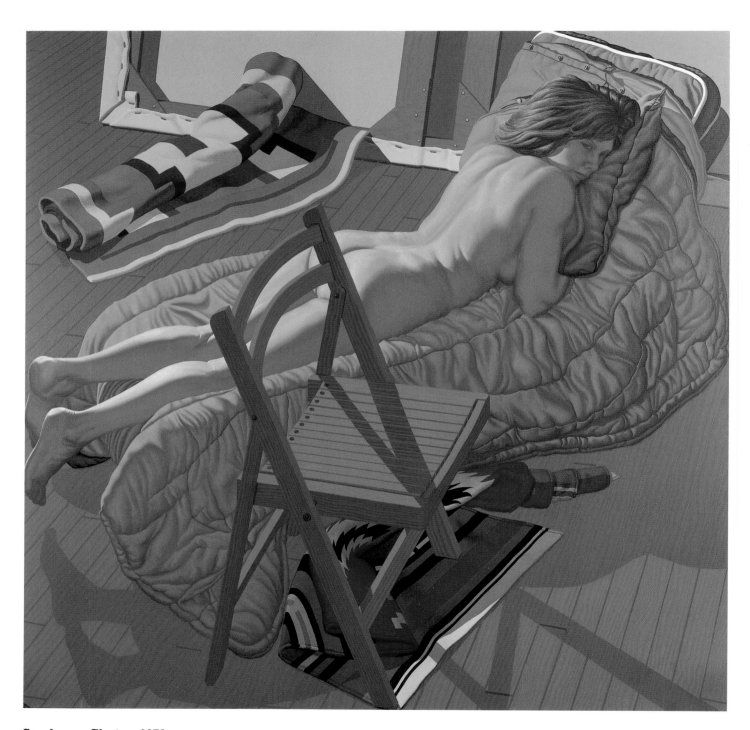

Sondra on Chaise, 1972
oil on canvas
68 × 68 in.
Private collection, New York

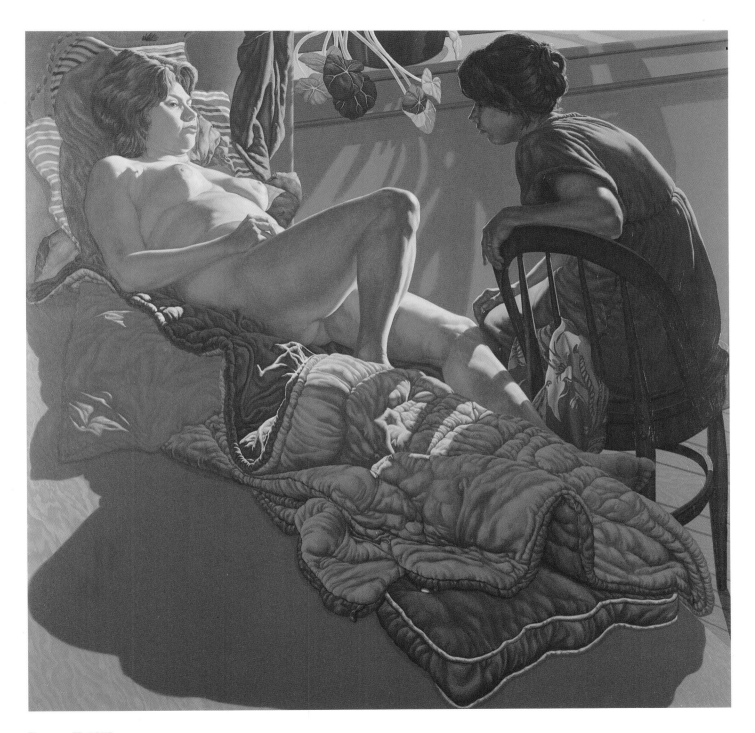

Danaë II, 1972
oil on canvas
68 × 68 in.
Whitney Museum of American Art. Purchase, with funds
from Charles Simon and an anonymous donor. 74.82

Danaë, which would easily explain the look of anomie apparent on the faces of both mistress and servant. As in the first treatment of the subject the responsiveness to light is a rich one.

Danaë II was to be virtually the last painting of a nude that Beal has produced. During 1973 and 1974 a retrospective exhibition of his work toured the Virginia Museum of Fine Arts in Richmond, the Boston University Art Gallery, and the Museum of Contemporary Art in Chicago. At this final venue the painter had yet another unfortunate experience that further disinclined him to go on painting the nude:

On the night of the opening in Chicago, the art director of *Playboy* magazine held a party for the occasion. A couple of days later one of his assistants telephoned me for permission to photograph some naked young women in front of my paintings. This made me feel so uneasy that I just stopped painting nudes from that point onward and I've only done drawings of the nude ever since. In oil paint you can approximate the appearance of flesh, while in pastels and other drawing materials that illusionism is greatly diminished, and so now I prefer to create unmistakable artificiality by only drawing the nude rather than painting it.

This renunciation of painting the nude was perhaps unfortunate, given the fact that many of Beal's most important paintings—including the two Danaë pictures—are representations of the female nude. Certainly that aversion might have been avoided if Beal had less of a highly developed moral sense, or if his desire to blur the distinctions between art and life was not so strong. After all, the quality of his best paintings of nudes resides not in the information they provide about anatomy, but in their emotional, pictorial, and psychological response to the nude and its surroundings.

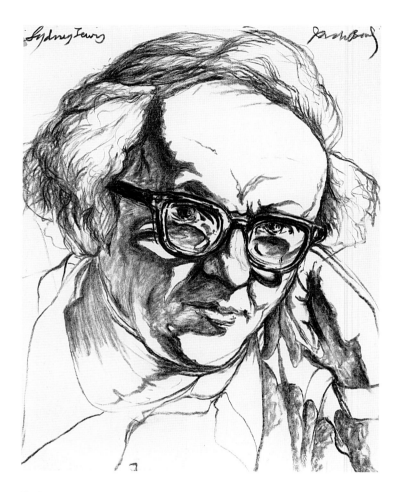

Sydney Lewis, 1974
charcoal on paper
$25\frac{1}{2} \times 19\frac{3}{4}$ in.
Sydney and Frances Lewis

Sydney and Frances Lewis, 1974–75
oil on canvas
72×78 in.
The Sydney and Frances Lewis School of Law,
Washington and Lee University, Lexington, Virginia

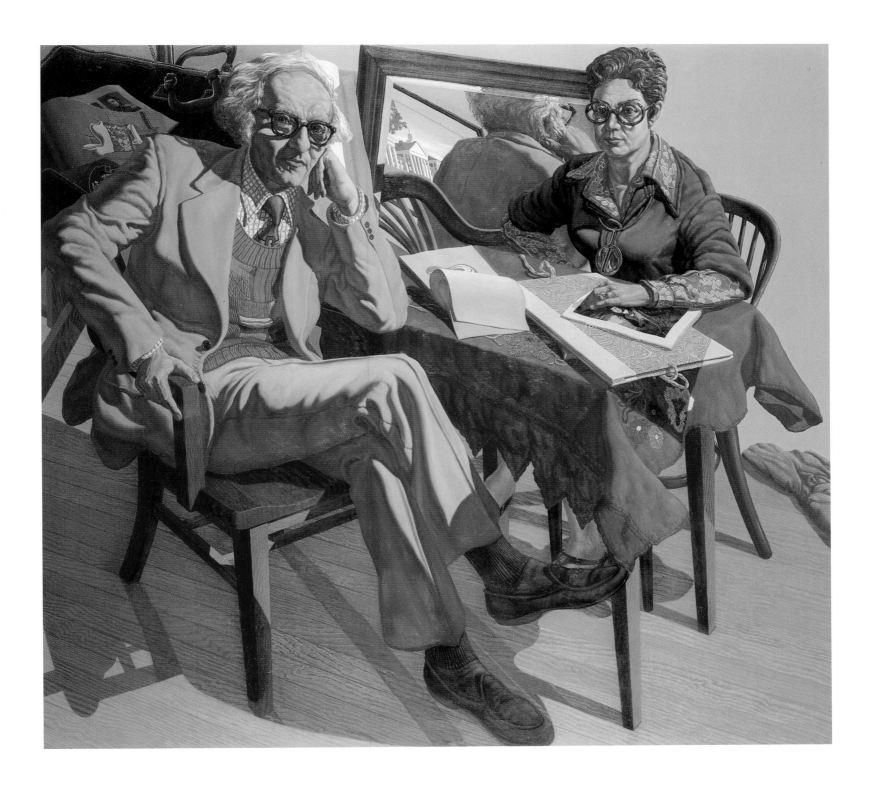

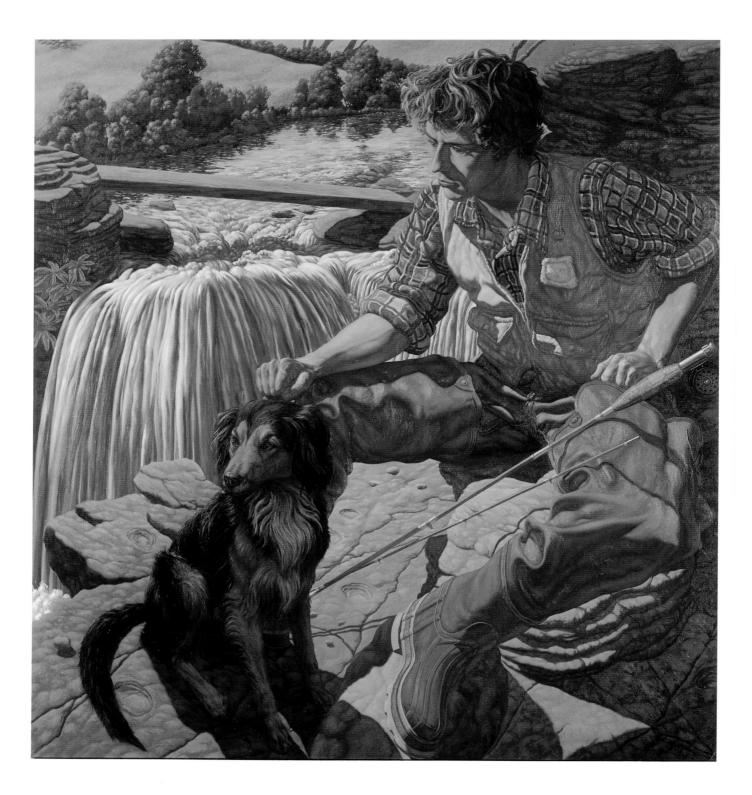

In 1973 the Beals came across a dilapidated old mill built over a trout stream in the Catskills, and they bought it the following April. This necessitated a total reconstruction over the next few years:

We poured our hopes, dreams, and almost all our money into the place. Sondra treated it as her last sculpture—she was the designer, the architect, the boss carpenter, and the gardener, I was the contractor and business manager. Sondra began making flower and vegetable gardens, even while building the house, and the gardens have continued to grow in size, number, intensity, and renown ever since. While all this was going on, I carved out time to paint, making a picture of a young man and our dog beside the waterfall—the painting, a daylight scene, was painted at night in our barn, and it was one of my first attempts at making a naturalistic picture away from the subject.

In 1974–75 Beal painted the visually and psychologically complex portrait of Sydney and Frances Lewis:

Washington and Lee University in Lexington, Virginia, asked if I would paint this portrait for the lobby of the new Law School that the Lewises had built for the university. This project was very rewarding because the Lewises are great people and good friends, while the portrait was intended to challenge the students—to exhort them to do their best. As a result I portrayed the Lewises—who are lively and genial among their friends—as stern and judgmental. Sometime later a Washington and Lee student confided to me that the portrait had "scared the tar" out of him, so I figure that I was successful.

The Fisherman, 1974–75
oil on canvas
67 × 62 in.
The Crispo Collection, New York

Increasingly during the 1970s a finer, more Flemish attention to visual detail can be witnessed in Beal's images, coupled with a far greater linear restlessness. Clearly the extra informational input was part of the painter's reconversion to Realism in 1969. And this tendency received a major impetus in 1974 when Beal was commissioned by the United States government's General Services Administration (GSA) to make four giant murals to adorn the new Labor Department Building on Constitution Avenue in Washington D.C. It was the first such mural commission awarded by the national government for a Federal office building in Washington since the great spate of mural commissions during the 1930s. Beal regarded the provision of a high degree of narrative information as a prerequisite of the works:

I welcomed the luxury of having an exact audience for these pictures in precisely the way that Renaissance masters had when they fulfilled large-scale public commissions. I had seen Piero della Francesca's *Story of the True Cross* frescoes in Arezzo, Italy, and they provided the role models for my own public works. In their murals the Renaissance masters were making moral messages for illiterate people, while I was equally making moral messages for visually uninformed people, a factor that also determined the nature of my imagery. And I was no less highly aware of the fact that the point of making the murals was to glorify the labor done by American workers, who never obtained any glory otherwise: they are never on the *Tonight* show; they never win the lottery; they are never going to be in *People* magazine. In order to effect their glorification I felt that I had to be as precise, informative—and even as corny—as I needed to be. I wasn't making these images only for artists and art critics. I wanted the images to reach out to working people, who had nothing else —they come to Washington and go to the Washington Monument, which doesn't relate to them; they go to the Lincoln Memorial, which doesn't relate to them—I wanted them to have a place to go that would speak directly to them.

To such an unashamedly populist end Beal determined to produce a set of pictures recounting the history of labor in America over the past four centuries, in which a direct, illustrative style—ultimately modeled upon the stylistic directness of the paintings of George Caleb Bingham—would service the narrative flow. Yet Beal did not find the immense challenge that these murals offered an easy one:

When I was offered the Labor Mural commission, the two people I depend upon most—my wife and my art dealer—advised me not to take it on. They said it would drive me crazy and make us broke —and they were right. But challenges like this come along all too seldom, and I jumped at the opportunity. I knew I had no experience in this area, and that I had not been adequately or properly trained for the job. There were no precedents in our own time—no one to whom I could turn for advice. So I had to negotiate with the government, devise a plan, and persuade the GSA to accept the concept of four separate paintings for the interior of the building, rather than the collagelike hodgepodge which they had envisioned should be mounted on an outside wall at the back of the building.

Beal created the murals with the help of five assistants:

Under the guidance of our great carpenter friend, Don Schriver, we built a new studio next to my house near Oneonta, in upstate New York, large enough to hold four twelve-by-twelve-foot canvases, the five people who worked on them, the many people who posed for them, and the equipment we needed. The painting team consisted of Sondra, who was the still-life specialist; Dana Van Horn, who was responsible for the landscape imagery; Bob Treloar, who dealt with the hard-edge work, and Bill Eckert, who blocked in much of the underpainting. I painted all the figures, mixed all the colors, and served as foreman. The persons represented in the pictures are all friends and neighbors, chosen because they are good people

and hard workers. They are farmers and school-children, art dealers and carpenters, a doctor, a contractor, two civil servants, an author, college students, painters, a sculptor, and even a grand-mother from Britain.

All the members of the painting team had to educate themselves for the monumental task ahead. We each undertook historical research, while I also studied the great religious and other public paintings of the fourteenth to twentieth centuries. Simultaneously I researched the workings of the Renaissance studios and made copies and studies of great drawings and compostions. To construct the designs, I first made "vignettes"—small studies of groups of workers in relationship to each other—and then began putting these groups together to create dynamic compositions as metaphors for the energies of the workers. After the compositions were finalized, layout drawings were then made, scaled up, and transferred to the canvases. For the seventeenth- and eighteenth-century murals we made three-dimensional scale models of the settings, because they are both outdoor scenes; the nineteenth- and twentieth-century murals needed no models—the activities represented in the paintings were very much like the energies of the studio itself.

Beal located most of the figures at the bottom of each canvas so that viewers can more easily identify with the people in the paintings. The murals were painted with the team working ten to twelve hours a day, seven days a week, for almost two years, and Beal spent the final couple of months bringing all the imagery together and imposing the stamp of his personality upon it. The process was very intense, and Beal is convinced that the reason for that intensity was the uniting "of the team in a common goal: making pictures for the American people." As these works are narrative pictures, it may help the reader if those narratives receive some explanation here.

In the first of the murals, *Colonization*, we see a seventeenth-century pioneer and his family who

have landed from the ship seen on the horizon on the right. The vessel is returning to Europe, and already the pioneer is felling timber on the left (next to which, on the walls in Washington, there is a large empty space, which, by association, perhaps suggests the vast empty spaces facing the pioneer). The pioneer's wife and two children prepare a meal, and also by the fire a fur trader in ornate colonial costume is dealing with a pair of fur trappers, one of them an Indian.

In *Settlement* we have moved on to the eighteenth century, with settlers adding an extension to an existing house. Here everyone is at collective labor, including the blacksmith, his apprentice, and the grandmother on the right who is preparing a meal for the toilers. For Beal "America was at its best in this period: there was no laziness; everyone was working towards a common goal; and I wanted the strength of the age to be reflected in the muscularity of the figures."

In *Industry*, which represents the nineteenth century, we look out through a textile mill to a sprawling, polluted, and scarred industrial landscape. The very strong leftward diagonal stress rising up the side of the mother leading her children out of the mill, and up the various belts and pulleys, was intended to symbolize the major underlying political tendency of the nineteenth century, namely the movement toward socialism. On the right some children are handing out strike signs, with a mill hand reaching out to obtain one, while on the left a seated mill owner looks disconsolate as his workers are politicized and go out on strike. Behind him a young black man carries bundles of rags which strongly pull his arms down, so as to suggest that he is "enslaved by his job."

Finally the twentieth century is represented by *Technology*. Here we are placed within an artificially lit interior setting for the first time, and only on the left can we make out a landscape, the dark, wholly industrialized vista of an oil refinery with its tanks and tubings. Beal intentionally made this mural the most confusing of all the images, so that we do not know precisely what most of the people are doing; the only figures who are clearly performing anything useful are the two electricians in the upper half of the scene. Beal intended this confusion to reflect the fact that America has changed from being a society that produces goods to a society that processes information, but only does so rather badly, possibly because people find it difficult to work up much enthusiasm for processing information. In a glass booth two men in white overalls (portrayals of Allan Frumkin and Jack Beal himself) examine a fragment of petrified wood similar to the one that appears between the woodcutter's feet in *Colonization*—thus returning the viewer to the beginning of the mural cycle—while a cameraman records their probing. At the left the black electrician perilously perches backward on a stepladder; his reversed position was intended to symbolize "the threatened position of black workers in our society—whenever there's a recession," asks Beal, "who gets laid off first but the black worker?"

The murals were completed not in upstate New York but in Manhattan, where Beal rented the large studio of his friend, Red Grooms. And in January 1977, when the images were nearly completed, the artist opened the New York studio to the public for ten days before sending the murals down to Washington:

The response was overwhelming. Several thousand people braved the bitter cold weather to come and look at the work. Quite a few older painters who had made murals for WPA projects in the 1930s showed up and told anecdotes of their own experiences. The art critics responded positively; for example, Hilton Kramer headlined his very encour-

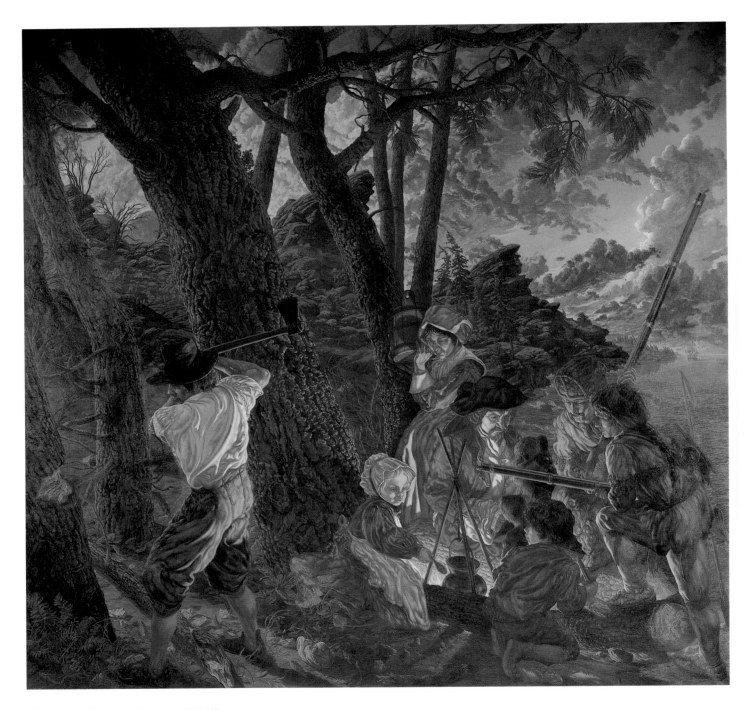

**History of Labor Murals: 17th Century—
"Colonization," 1974–77**
oil on canvas
146 × 150 in.
U.S. Department of Labor, Washington, D.C.

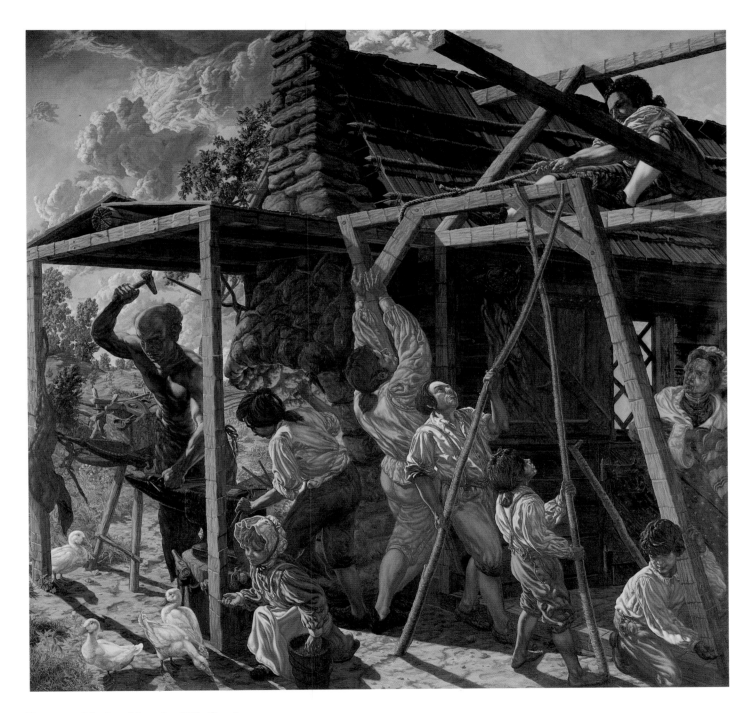

**History of Labor Murals: 18th Century—
"Settlement," 1974–77**

oil on canvas
146 × 150 in.
U.S. Department of Labor, Washington, D.C.

History of Labor Murals: 19th Century—"Industry,"
1974–77
oil on canvas
146 × 150 in.
U.S. Department of Labor, Washington, D.C.

**History of Labor Murals: 20th century—
"Technology," 1974–77**
oil on canvas
146 × 150 in.
U.S. Department of Labor, Washington, D.C.

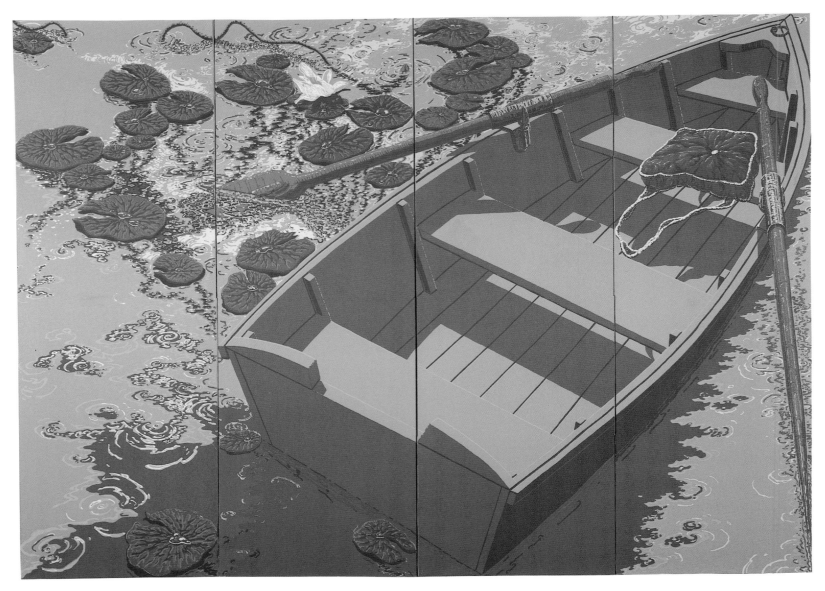

Rowboat, 1977
silkscreen (four-panel folding screen)
$71\frac{1}{2} \times 95\frac{1}{2}$ in.
Frumkin/Adams Gallery, New York

aging review in *The New York Times*, "One-Man Mural Revival." Soon afterward, the dedication ceremony in the Labor Building provided an intense experience—almost all the people who had posed for the murals appeared, and four of them pulled back the curtains shrouding the canvases; the U.S. Navy Band and Sea Shanty Singers performed; the wife of the Vice-President, Joan Mondale, and other dignitaries made speeches; and we basked in the glory.

Beal rates these murals quite highly within his oeuvre, but our aesthetic perspective on them will undoubtedly be conditioned by our views about populist imagery and the role of public art. In the images Beal made little use of the kind of allusiveness that is such a feature of the Danaë paintings and other works. Visually they sometimes display spatial and proportional disjunctions, perhaps because Beal is not used to working on such a scale. But what the images do possess is linear flow and energy, dynamics that are by no means always present in large-scale works of public art. The murals surely come within hailing distance of some of the best American socially aware murals, such as Thomas Hart Benton's New School for Social Research panels (now in the Equitable Life Assurance Building in New York), works that have only recently come to be appreciated again. Indeed, the comparison with Benton is a fruitful one, for clearly the tradition of public art to which he contributed, and of dealing with popular issues in an unabashed way, is not a dead one but has been carried into our own time by Jack Beal.

Far from taking a long rest after completing the Labor Department murals, Beal threw himself even more into his work, creating *Rowboat* of 1977, a very lyrical four-panel, multicolored serigraph folding screen of a rowboat and waterlilies on a pond, as well as several detailed portraits, such as the *Self-*

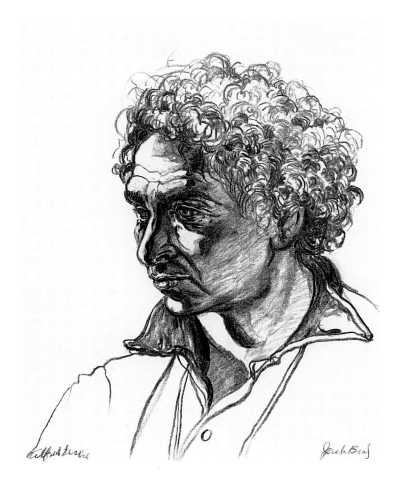

Alfred Leslie, 1977
charcoal on paper
$25\frac{1}{2} \times 19\frac{5}{8}$ in.
Collection the artist

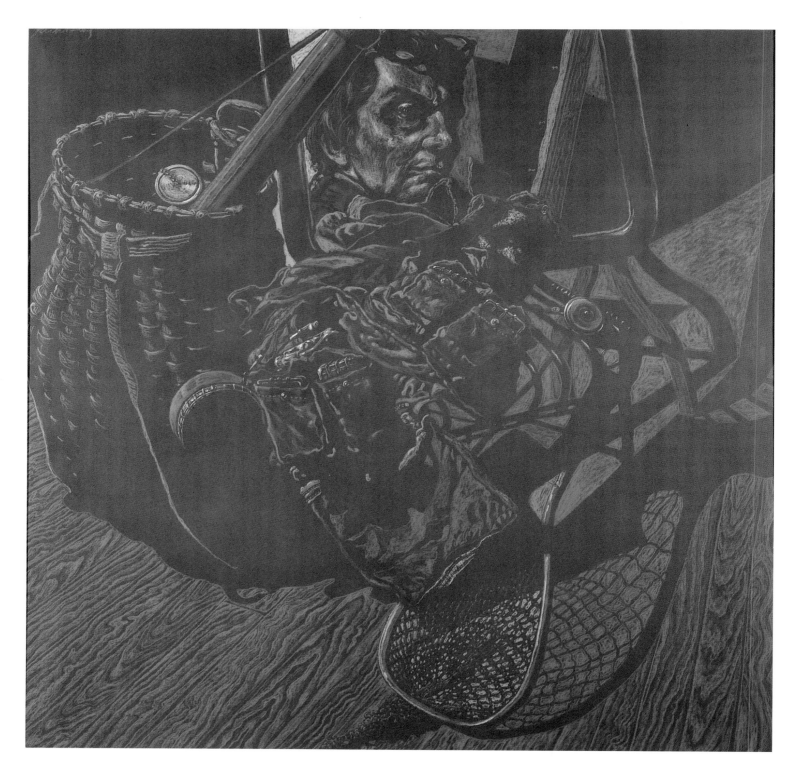

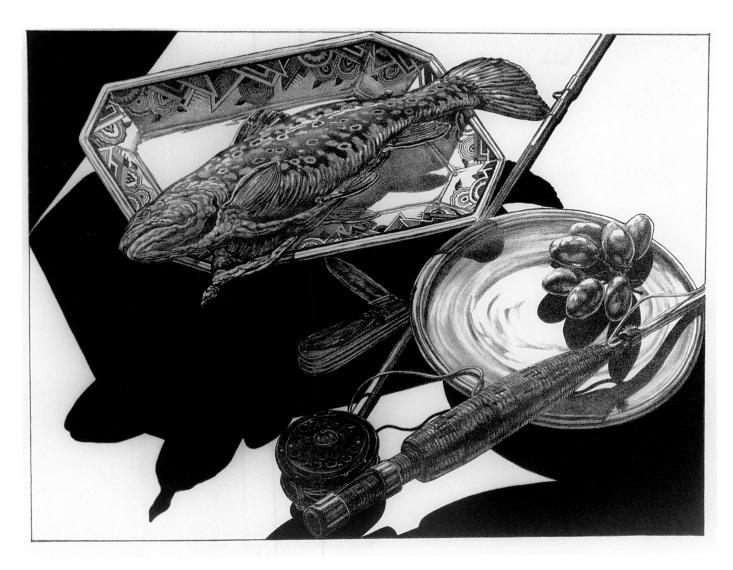

Trout, 1977
color lithograph (in nine colors)
edition 102
$19\frac{3}{4} \times 25\frac{3}{4}$ in.
Brooke Alexander Gallery

Self-Portrait with Fishing Gear, 1977
pastel on gray paper
45×45 in.
Mr. & Mrs. Shelley B. Weinstein Collection

Girl Reading, 1971
oil on canvas
60 × 48 in.
Susan Frankel Ruder

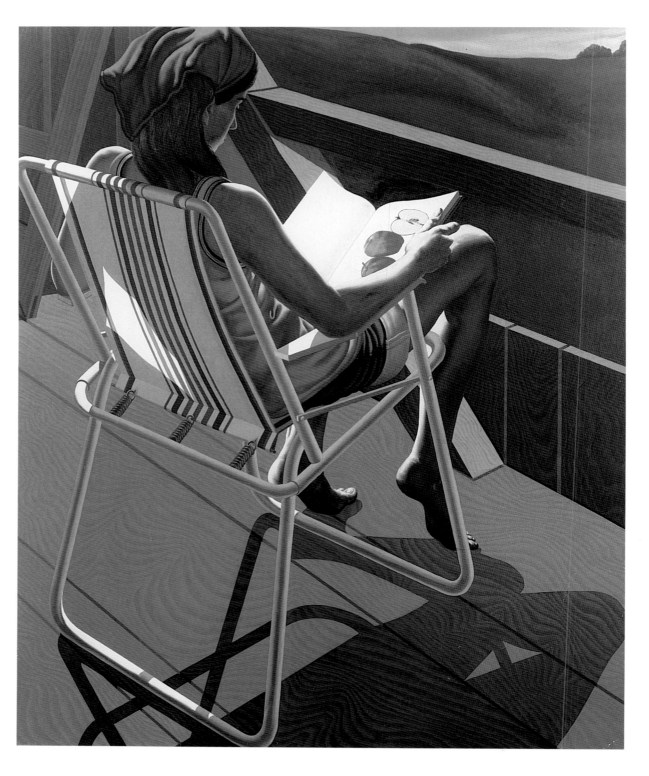

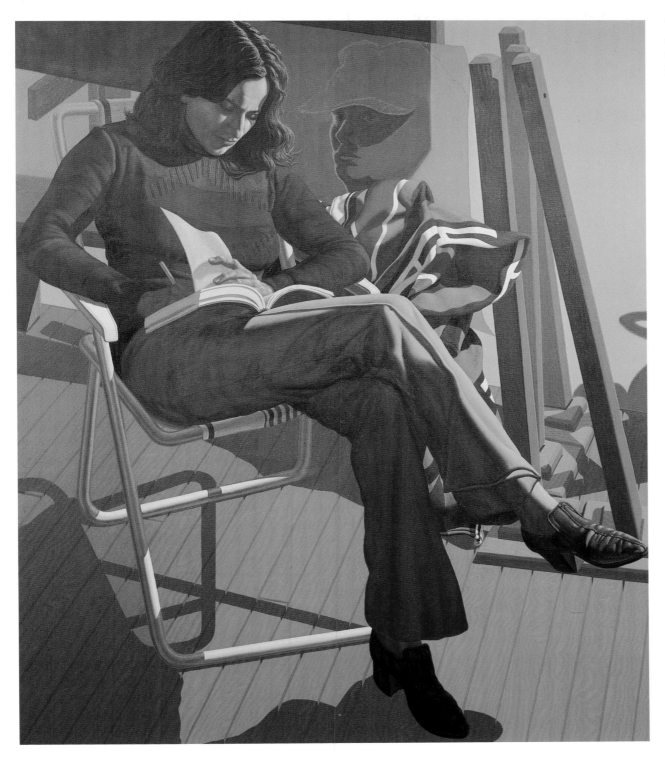

The Architect, 1972–73
oil on canvas
60 × 50 in.
Private collection, New York

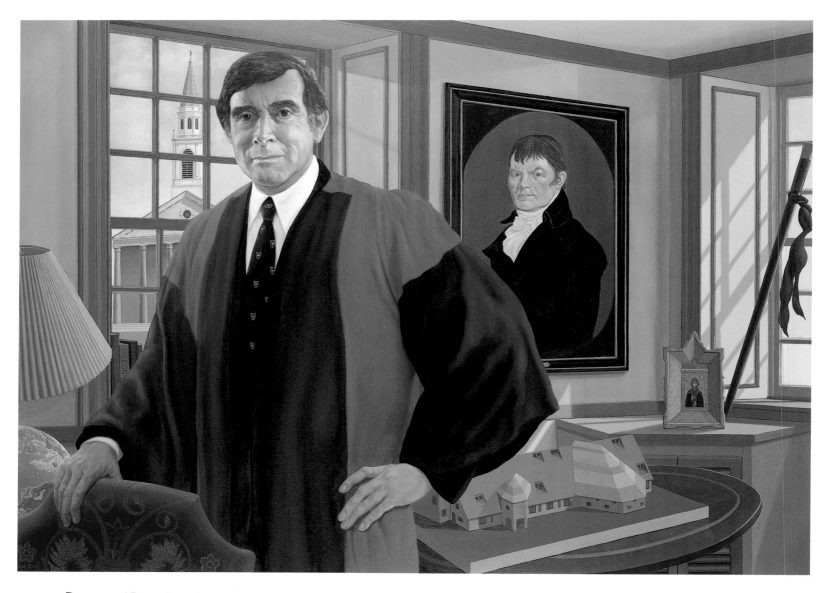

Portrait of President Olin C. Robison, 1989

oil on canvas

48 × 66 in.

Christian A. Johnson Memorial Gallery, Middlebury
College, Vermont

Portrait with Fishing Gear of 1977 and the portrait of Alfred Leslie of the same year. Beal regards portraiture as a major way of relating psychological and pictorial concerns:

I have made a number of portraits, some commissioned and some for my own edification and pleasure. Often these are self-portraits, for several reasons—posing is a long process, and I hate to take up other people's time; but, more so, because I like to work with chiaroscuro and that involves *precise* placement of the light and shade, a placement most easily obtained if the artist is also the subject. In other people's portraits I have often felt like a headhunter, robbing the soul and spirit of the sitter. In order to get the intensity I need, I peer relentlessly at the sitters. In *The Architect* of 1972–73 I have shown the sitter studying, thus keeping the intensity inside the picture. But in the *Portrait of President Olin C. Robison* of 1989 the subject is confronting the viewer aggressively, just as the Lewises are doing in my portrait of them. However, in the Robison portrait the intensity is more single-minded—Dr. Robison is standing in a "power pose," hand on hip and completely frontal. In *M.H., M.B.* of 1987 the sitter—who is another architect and a close friend—has his eyes averted from the viewer. Since the picture owes something to Thomas Cole's *The Architect's Dream,* I showed two of *this* architect's works behind him, and tried to depict his role as a visionary by having him avoid eye contact with the viewer.

By the mid-1970s Beal and his wife were happily ensconced in their country house, which they had continued to improve. Sondra Freckelton worked energetically both on the gardens and on her own art—she had undergone a major conversion to painting after her participation in the mural project —and very quickly she became one of the best-known Realist watercolorists around. Using the creative drive and determination that she had put into designing and building the house and gardens,

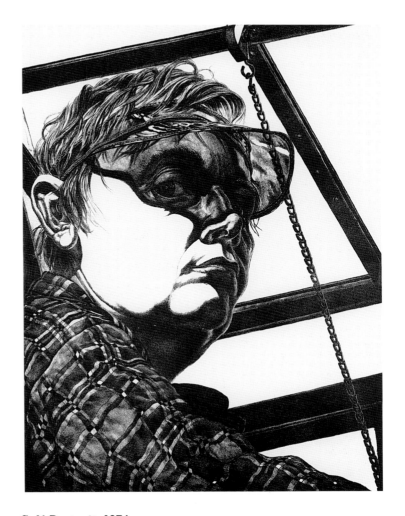

Self-Portrait, 1974
lithograph
$26\frac{7}{8} \times 20\frac{1}{2}$ in.
Frumkin/Adams Gallery, New York

and exploiting the spatial sensibilities she retained from her work as a sculptor, soon she created an impressive body of work. Beal sees their creative life together as all of a piece:

We both believe in beauty as a positive force in the world, and that it is the artist's job to create beauty. We try to make beauty as an antidote to destruction, order as opposed to chaos, to celebrate intelligence and denigrate ignorance. We agree wholeheartedly with Eldridge Cleaver's elegantly simple statement, "If you're not part of the solution, then you're part of the problem."

During 1977 and 1978 Beal embarked upon a series of highly complex allegorical paintings. These represent the Virtues and Vices; four of them in the separate pictures *Pride*, *Envy*, *Fortitude*, and *Sloth*; the rest in two composite works, *Hope*, *Faith*, *Charity* and *Prudence*, *Avarice*, *Lust*, *Justice*, *Anger*, which brings together two virtues and three vices (a further work, yet to be completed, will unite Gluttony and Temperance). Beal's reason for creating this group of works is quite simple: he thinks that there is a place for art moralism in our society, just as there was in the cultures of Shakespeare and Alexander Pope (two of the moral artists that he most admires), and he regards artistic moralism as a challenge:

I wanted to take a contemporary look at an age-old issue—the struggle between good and evil. These concepts have changed, and our feelings about the virtues and vices have altered radically. For example, in medieval times Pride was the deadliest of the Seven Deadly Sins, whereas today we think of it as a virtue. Similarly almost none of my friends whom I asked to pose wanted to represent a virtue—indeed, most of them wanted to personify lust! The world has turned upside down. These paintings drew some unfriendly fire from the critics, mostly because of the subject matter,

but I have noticed that many other artists are now dealing with similar themes, and I wanted people to think about the issues. I admit that the issues came first and the images came later, which is perhaps why the pictures are rather illustrative. But I felt that America has been going through a profound moral crisis, and I wanted to deal with that. We've been reexamining everything, but it's only recently that some people have decided that everything that came before us is junk, which notion is itself total junk. I thought that examining moral issues was eminently worthwhile. The world needs leadership. Few of us get it at home; we don't get it at school. Few of us go to church, so we don't get it there either; and although painting is not necessarily the best vehicle for moralizing, nonetheless it can be a moral vehicle for people who don't attend church or read philosophy.

The Virtues and Vices pictures contain fine passages of observation, anatomical and other modeling, and linear energy; and they also put a healthy strain upon the viewer to puzzle out their meanings. For example, in *Prudence*, *Avarice*, *Lust*, *Justice*, *Anger* it is a little difficult to know exactly which figure represents which virtue or vice, although committed looking should soon supply the answers. Far less problematic in terms of our understanding of their precise meanings are those many intimate still-life pictures and floral pieces that Beal has created from the late 1970s to the present day. Here the visual engagement is keen, the color sense and responsiveness to form elaborate and fluent, and the sensuality that is an important part of Beal's nature has been given full rein.

Jack Beal underwent two lengthy periods of painterly inactivity during the 1980s. In 1981 both he and his wife became seriously ill with Chronic Fatigue Syndrome (an illness possibly caused by a super-sufficiency of the immune system), and they were almost completely bedridden for about nine months,

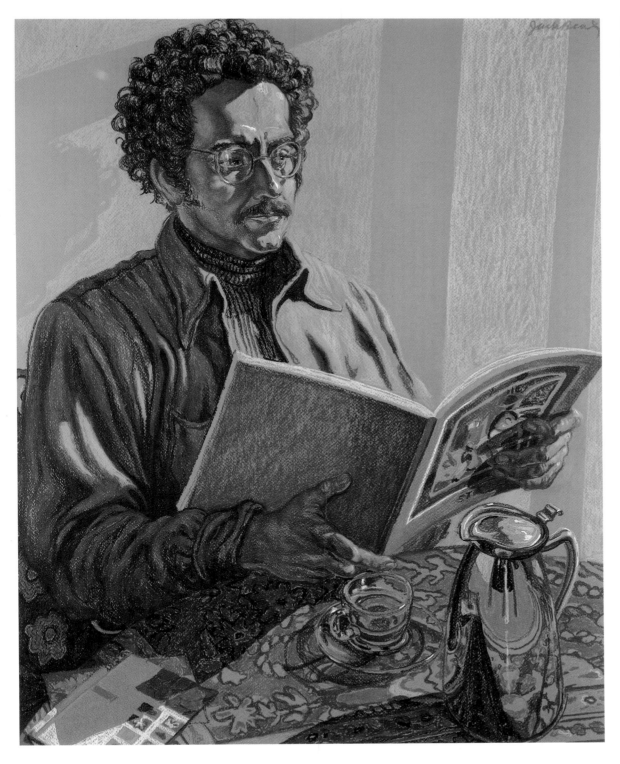

Pride, 1977–78
pastel on paper
40 × 32 in.
Martin Sklar

Self-Portrait with Cap and Lenses, 1982

pastel on paper
25½ × 20 in.
Dr. Eugene A. Solow

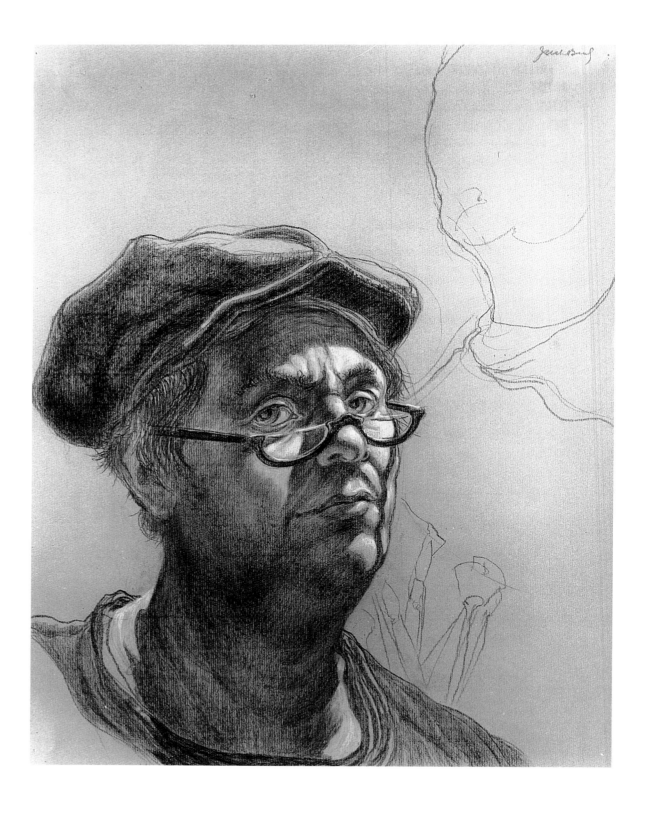

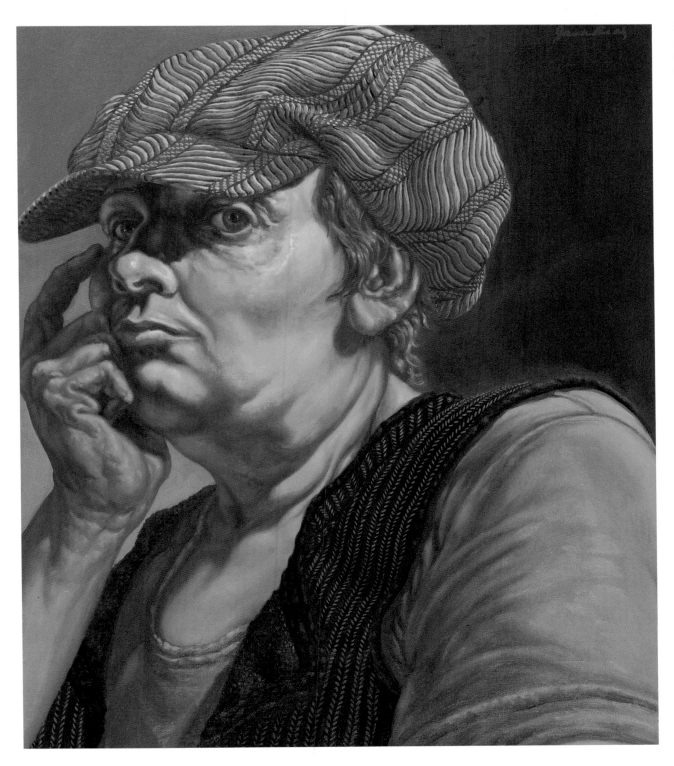

Envy, 1977
oil on canvas
26 × 22 in.
Sidney and George Perutz

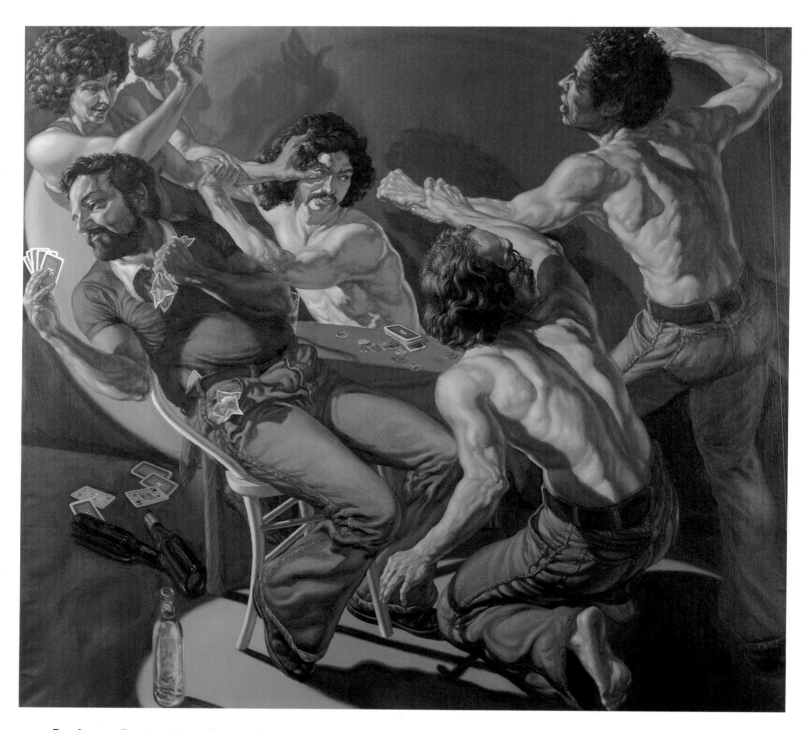

Prudence, Avarice, Lust, Justice, Anger, 1977–78
oil on canvas
72×78 in.
Bayly Art Museum of the University of Virginia,
Charlottesville

Hope, Faith, Charity, 1977–78
oil on canvas
72×72 in.
G.U.C. Collection

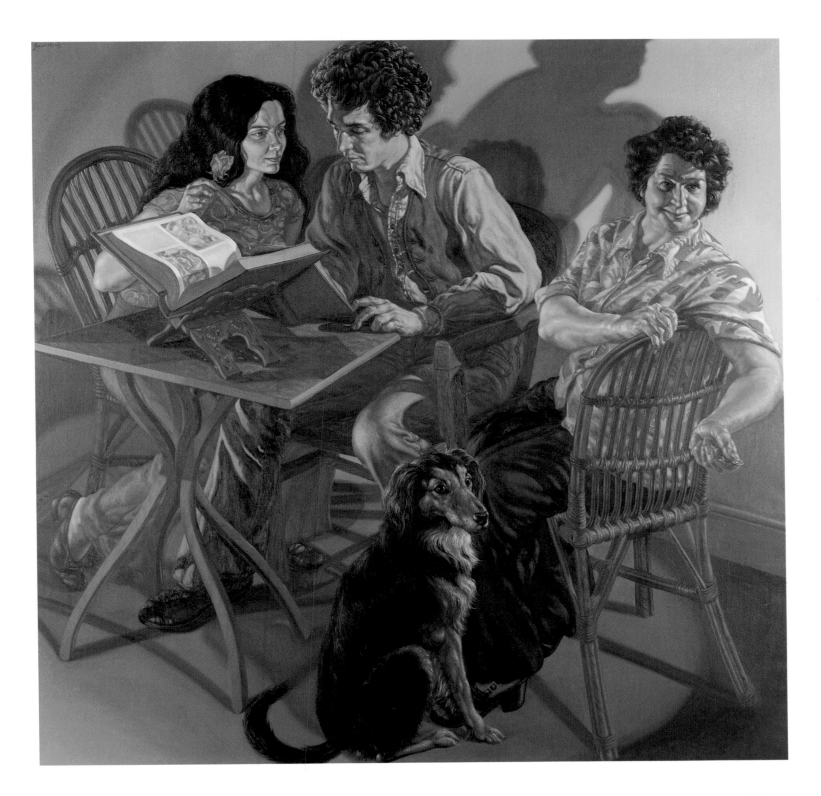

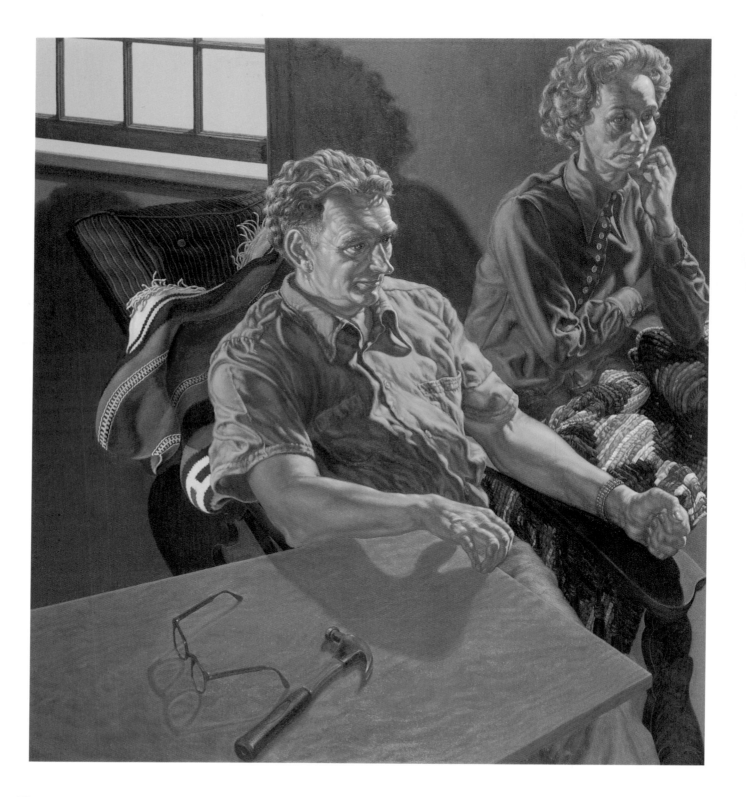

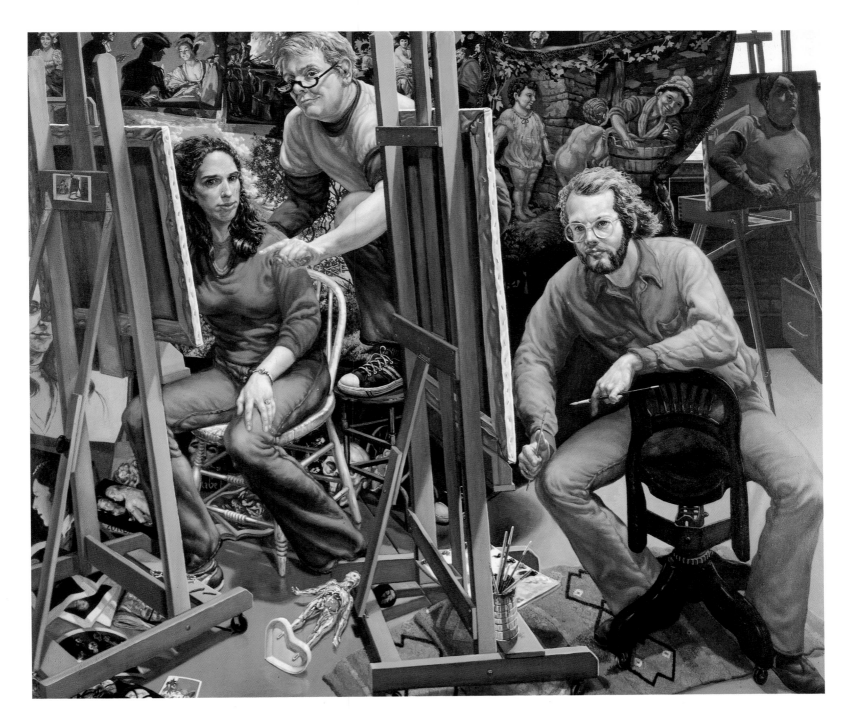

Fortitude (The Schrivers), 1977
oil on canvas
60 × 54¼ in.
Virginia Museum of Fine Arts, Richmond—Gift of the
Sydney and Frances Lewis Foundation

The Painting Lesson (To W. M.), 1983
oil on canvas
84 × 96 in.
Hunter Museum of Art, Chattanooga, Tennessee—Gift of
Mr. and Mrs. John T. Lupton

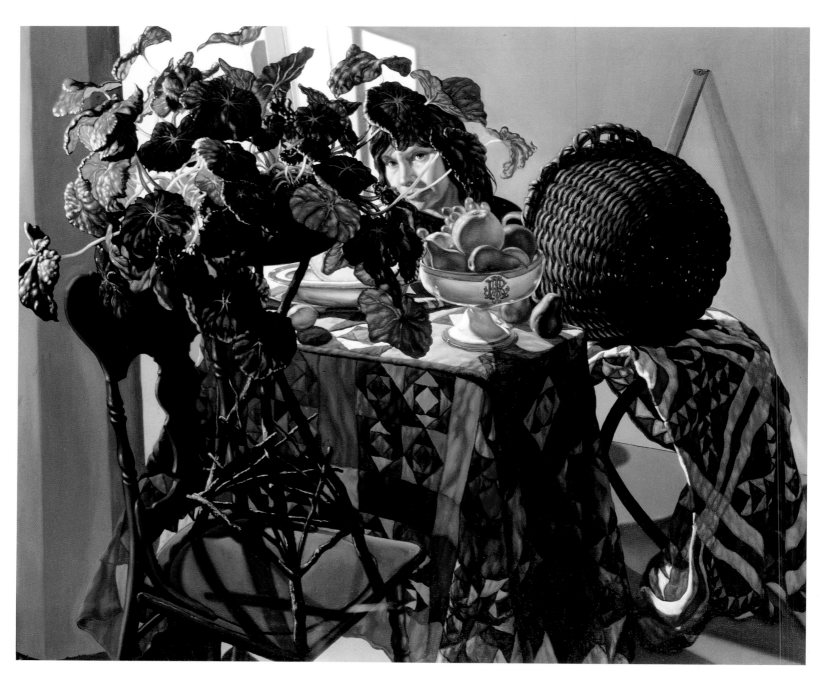

Still-Life Painter, 1978–79
oil on canvas
50 × 60 in.
The Toledo Museum of Art, Toledo, Ohio. Purchased
with Funds from the Libbey Endowment; gift of Edward
Drummond Libbey. Toledo Museum of Art 1979

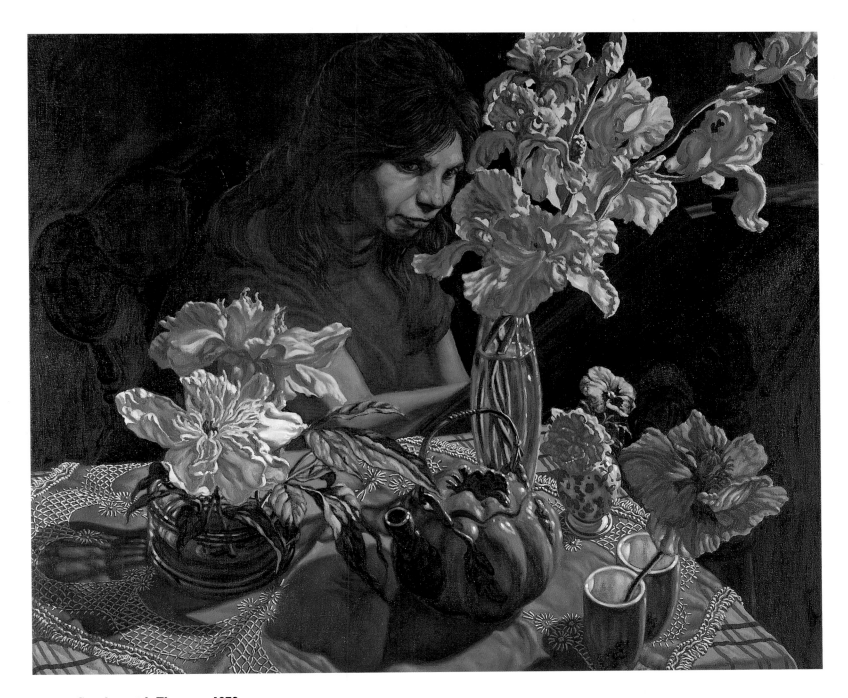

Sondra with Flowers, 1979
oil on canvas
32 × 38 in.
Galerie Claude Bernard, Paris

with great weakness manifesting itself for years afterwards. A further period away from the studio followed in 1985 and 1986 when Beal took nearly two years off from painting to throw himself into educational work, feeling it important to pass on everything he had learned so far about painting. It was a very rewarding experience, for clearly Beal has the ability of a born teacher to empathize with his students and bring out the best in them. And as well as fostering the age-old apprenticeship method of training artists, Beal has also supported other educational initiatives: he was one of the founders of the New York Academy of Art and the Artist's Choice Museum, both of which are manifestations of the upsurge of interest in Realist art; and he founded and directed the Realist programs of the La Napoule Art Foundation in Europe and America. He has served as visiting artist, critic, and lecturer at something like one hundred institutions of learning, and is adamant that a traditionally minded art education is a vital way of countering the cynicism, intellectual vacancy, empty cleverness, and negativism that permeate much art practice today.

A pictorial reflection of Beal's didacticism is the picture of 1983, *The Painting Lesson (To W. M.)*, in which he represented life in his studio and articulated the importance he places upon teaching and apprenticeship as a way of upholding The Great Tradition of Western Painting, a tradition that is denoted within the work by the many reproductions of old master pictures that appear there. These reproductions were painted not by Beal himself but by one of his pupils, Dean Hartung—the figure in the green shirt in the painting—as part of the ethos of the work. As Beal comments:

Dean Hartung's painting of those areas was itself a painting lesson. I urge all my students to copy the old masters, and Hartung did it so well that I barely needed to retouch the areas he painted. Dean and his wife, Ellen Hutchinson—the other figure apart from myself in the picture—have gone on to successful careers as painters.

The Painting Lesson (To W. M.) was perhaps the most complex work that Beal produced in the years immediately after his 1981 illness, for at first he had only been able to summon up enough strength to paint small, intimate pictures. Among the best of these are the *Self-Portrait with Daffodils* of 1982, one of the first works that Beal made after he had recovered from his illness; and the painting *Anne Wilfer Drawing* of 1982–83. Here the artist kept "the important subject matter away from the center of the picture" by distributing it around the brightest area, namely the part of the sitter's dress that catches the light, and whose abstractness of shape is thereby emphasized. He also produced large numbers of pastel drawings and prints and a number of fine self-portraits, such as *Self-Portrait with Anatomy No. 2* of 1986, in which he expressed his awareness of mortality by placing himself in proximity to skulls and skeletons, which act as *momento mori*. He has also been painting an ongoing series of pictures dealing with the senses. So far he has completed *The Sense of Sight (to D. M.)* of 1986–87, a modern allegory crowded with optical instruments and tools, such as spectacles and cameras, as well as reproductions of pictures by other painters; *The Sense of Smell* of 1987, which represents a young woman drawing a night-blooming cereus flower; and *The Sense of Hearing* of 1989. This last painting shows

Anne Wilfer Drawing, 1982–83
oil on canvas
54 × 50 in.
Dr. Gerard and Phyllis Seltzer

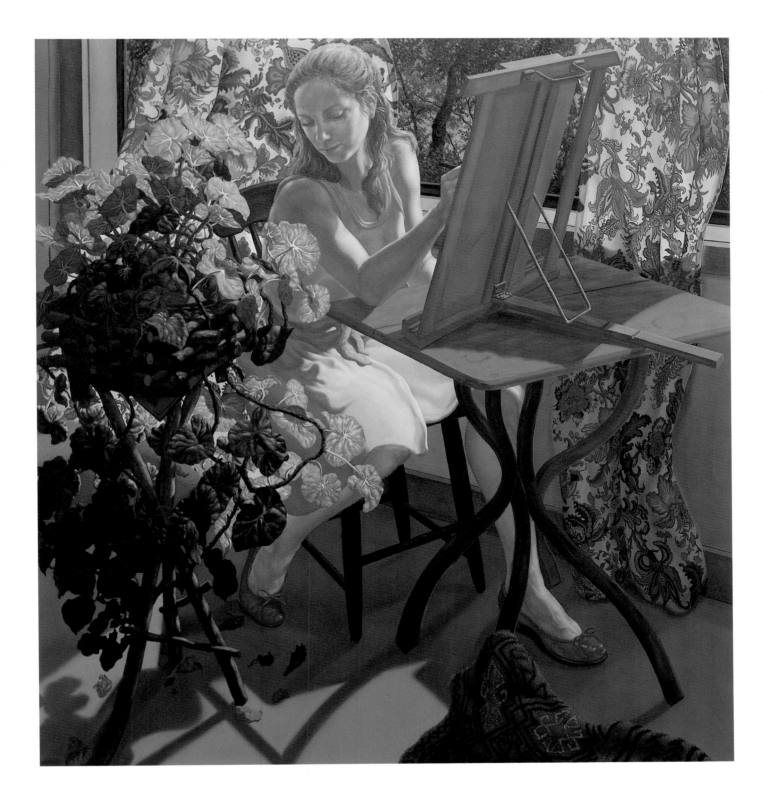

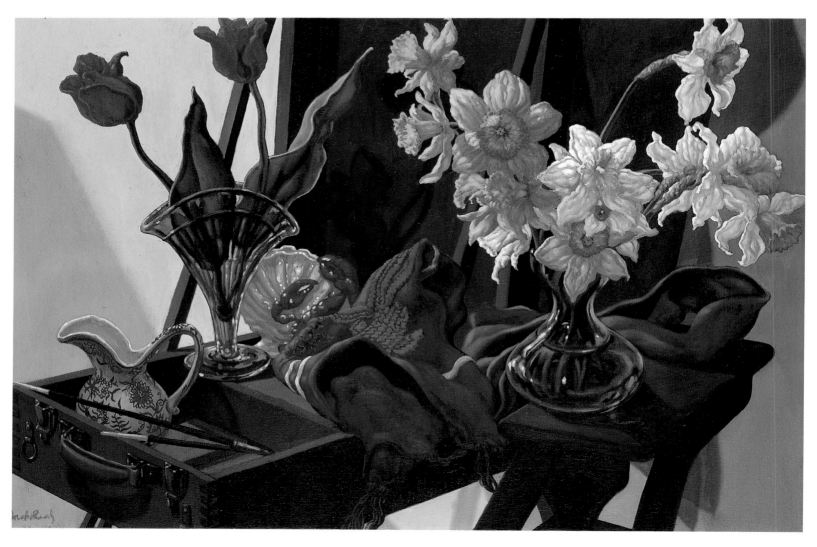

Still-Life with French Easel, 1982
oil on canvas
24 × 36 in.
Dr. Gerard and Phyllis Seltzer

<div align="right">

Self-Portrait with Daffodils, 1982
oil on canvas
36 × 36 in.
Malcolm Holzman

</div>

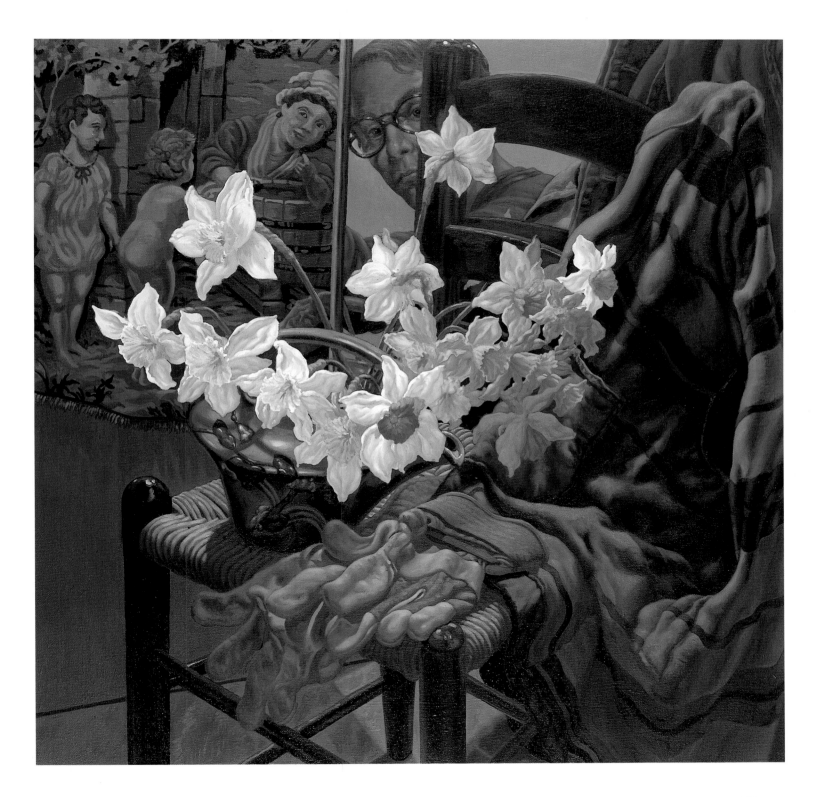

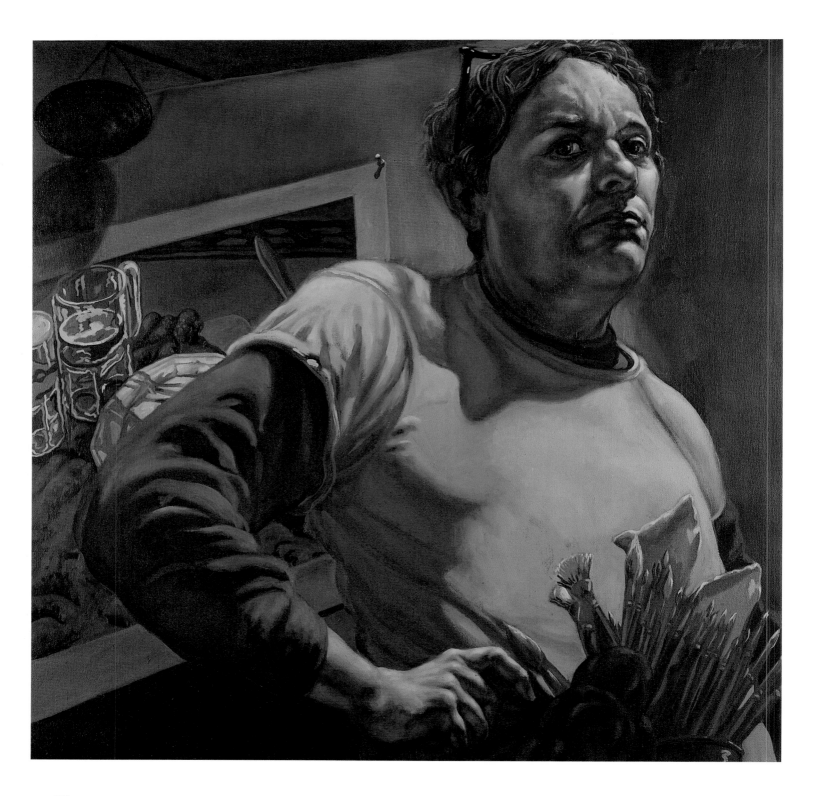

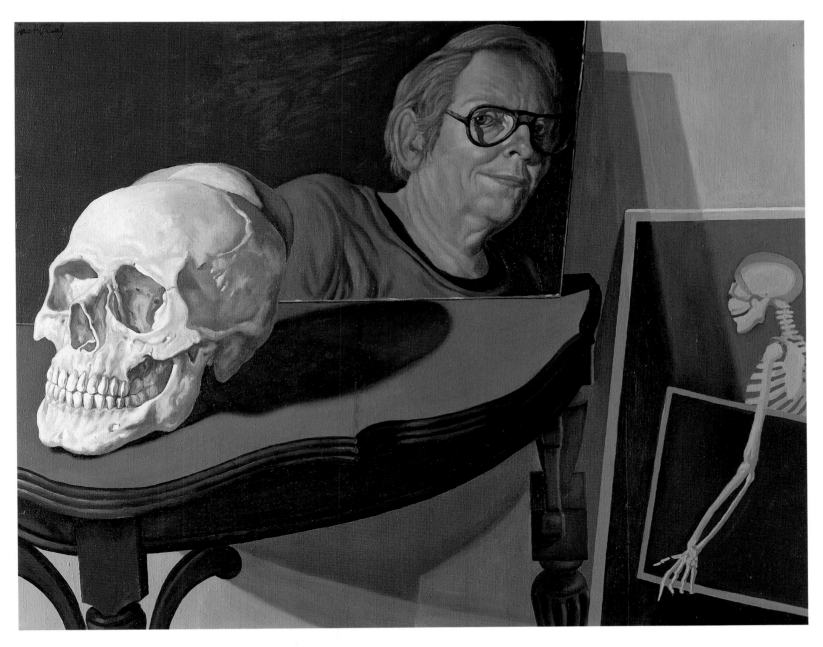

Skowhegan Self-Portrait, 1981
oil on canvas
36 × 36 in.
Diane and David Goldsmith

Self-Portrait with Anatomy No. 3, 1986–87
oil on canvas
24 × 30 in.
Frumkin/Adams Gallery, New York

**Self-Portrait with Anatomy
No. 2, 1986**
pastel on board
40 × 32 in.
Frumkin/Adams Gallery,
New York

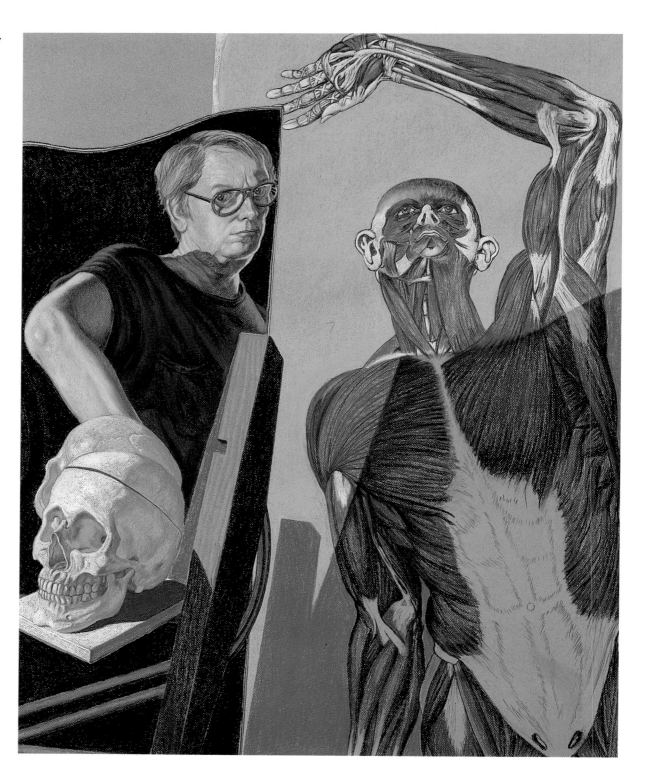

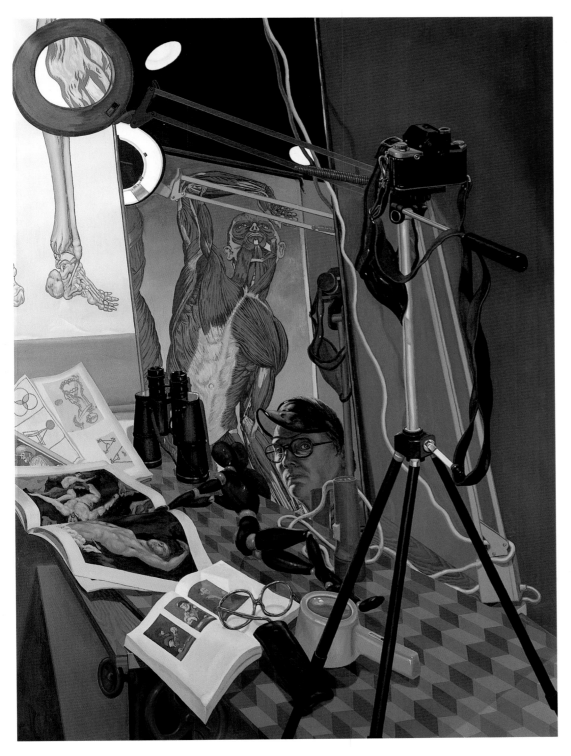

**The Sense of Sight (To D. M.),
1986–87**
oil on canvas
66 × 48 in.
Donald A. Morris, M.D.

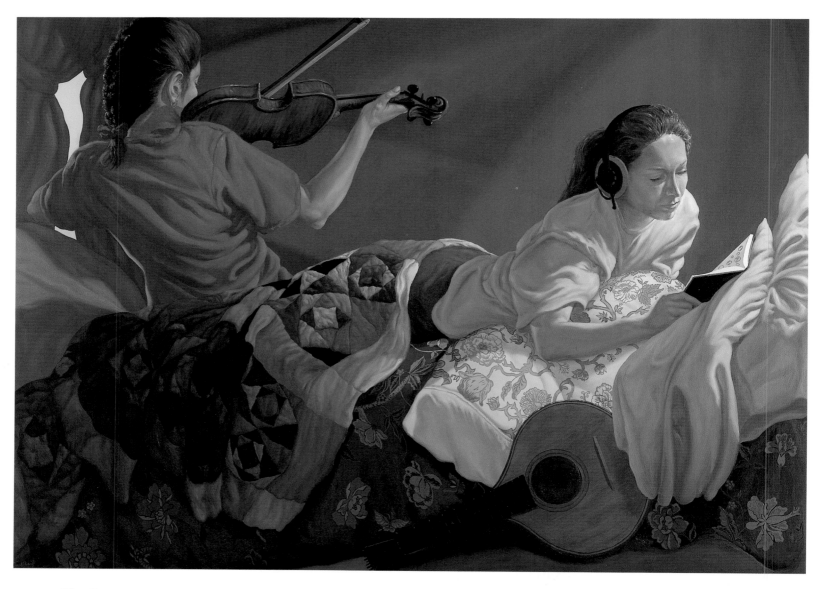

The Sense of Hearing, 1989
oil on canvas
48 × 66 in.
Private collection

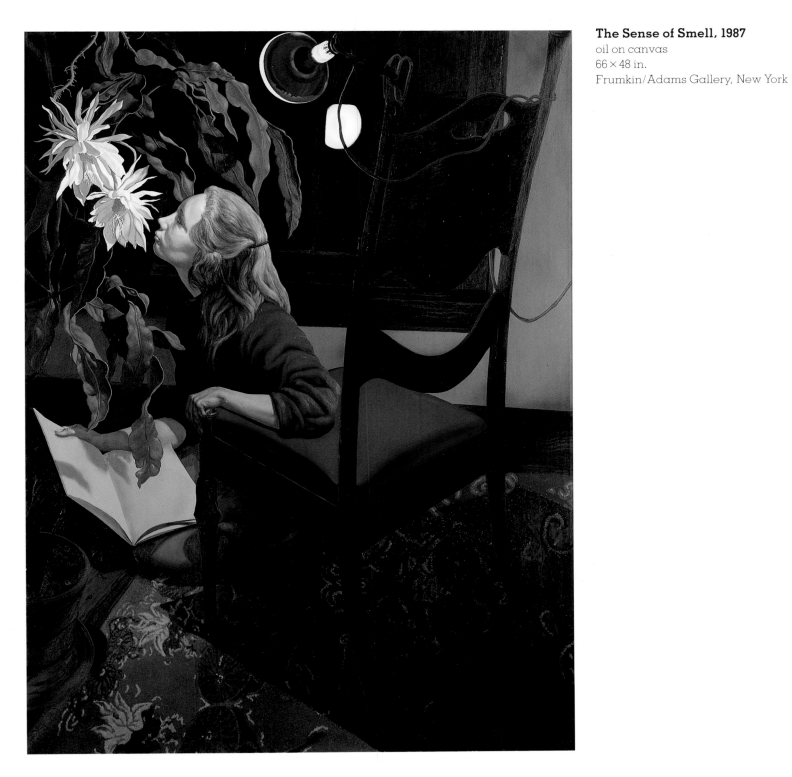

The Sense of Smell, 1987
oil on canvas
66 × 48 in.
Frumkin/Adams Gallery, New York

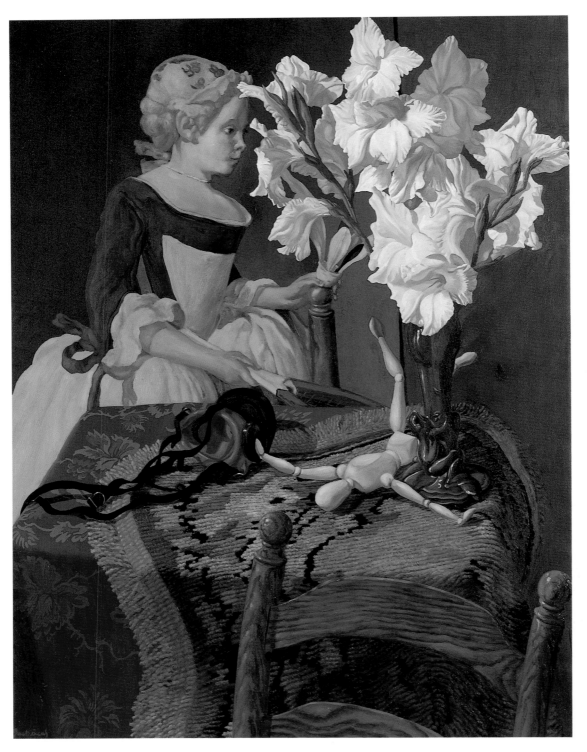

Still-Life with Gladioli (Homage to Chardin), 1989
oil on canvas
40 × 30 in.
Private collection, New York

Sunflowers, 1991
oil on canvas
36 × 36 in.
Mr. and Mrs. Joseph Carter,
Kansas City, Missouri

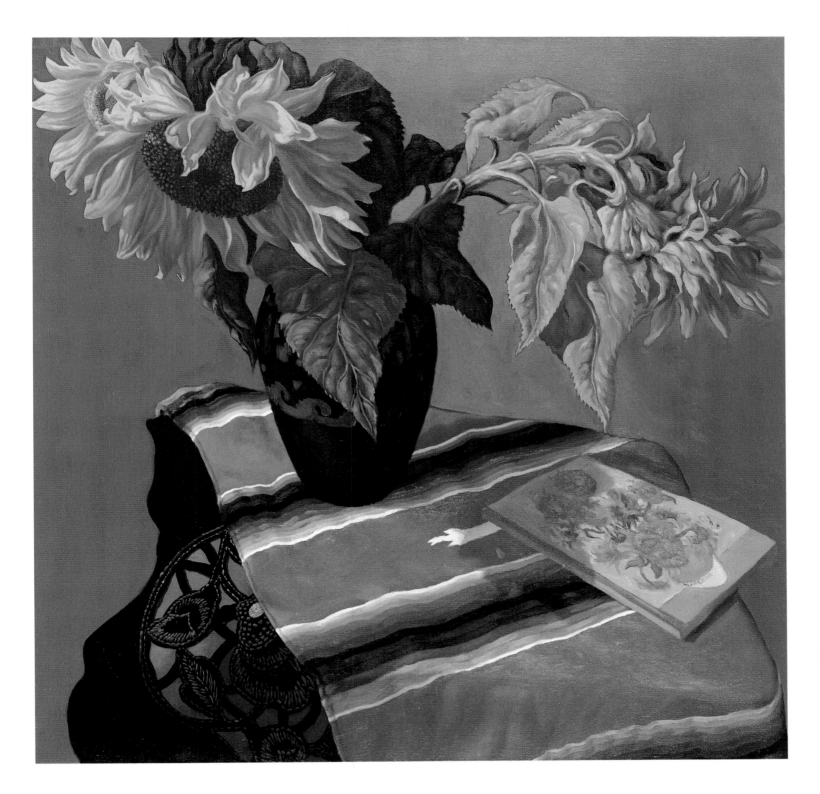

a violinist playing to a reading girl who is oblivious to the live music making, for she is listening to other music through headphones; Beal regards such a cutoff as symptomatic of the arts in our time. Further pictures in this series will represent taste and touch. Because in these works Beal has been able to allegorize by indirect means (just as he had earlier treated classical mythology indirectly in the Danaë paintings), the things that excite him visually have been allowed to dictate the proceedings, and the result has been a group of works that are fresh and vigorous.

Jack Beal is now sixty years old and still charged with energy, albeit not the kind of immense energy that evidently he enjoyed before 1981. He is articulate, dedicated, voluble, and full of the kind of healthy idiosyncrasy that is part and parcel of any true artist's personality. He has been responsible for a serious body of work, and at his best he has created images of complexity and feeling, pictures that have certainly placed representationalism back on the agenda of serious art. If occasionally he has overreached himself (perhaps deliberately), equally he has created many pictures that fully project visual poetry and emotional complexity.

This last quality is perhaps not surprising, for Beal is an emotional man and essentially an emotional painter. His emotionalism was allowed full articulation in the early expressionistic works but was kept in check during the 1960s by the need to balance feeling with thought. Where the painter has allowed thought to tip this balance over, and eradicate the feelings he holds toward a precise set of forms he has observed in front of him, then the results have sometimes been problematic pictures. But at heart Beal is a lover of visual beauty, and that love has often found its finest expressions in his portrayals of his wife in the nude, as well as in his many representations of flowers, other still-life objects, and areas of patterning. Where human representation is concerned, again Beal has been at his strongest when he has allowed purely visual considerations to dominate. And in his best paintings he has given us rich images that enjoy the power equally to delight us visually, move us emotionally, and stimulate us intellectually. There are many recent, and perhaps more highly regarded, American artists for whom one could not necessarily make that claim.

Interior with Waders, 1964
oil on canvas
60 × 69 in.
Frumkin/Adams Gallery, New York

Princeton Still-Life with Trap, 1966
oil on canvas
48 × 48 in.
Weatherspoon Art Gallery, University of North Carolina,
Greensboro—Gift of Blue Bell Corporation

Table No. 10, 1969
oil on canvas
68 × 64 in.
Collection the artist

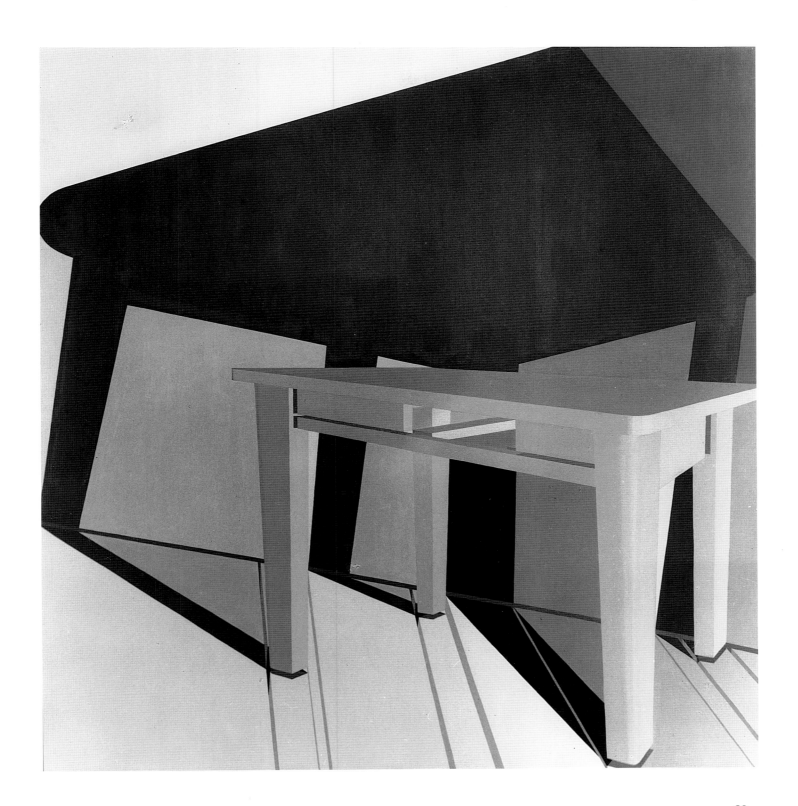

Seated Female Model, 1977
pastel on paper
27 × 19¾ in.
Ronald and Andrea Sandler

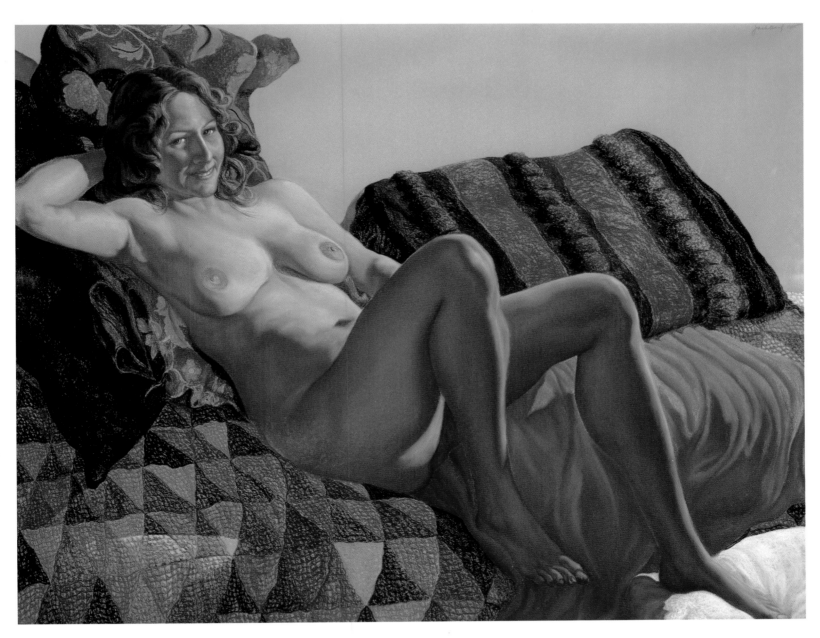

Patty, 1985
pastel on paper
48 × 60 in.
Mrs. Mildred Gosman

Drawing from the Model M, 1985
pastel on paper
$20 \times 25\frac{13}{32}$ in.
Alice Adam, Chicago

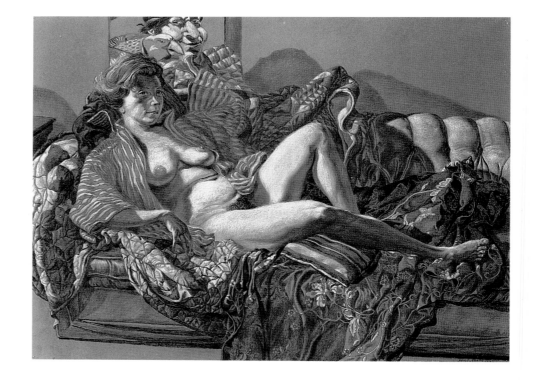

Drawing from the Model P2, 1985
pastel on buff paper
20×25 in.
The Arkansas Art Center
Foundation Collection, Little Rock.
The Tabriz Fund, 1986. 86.20

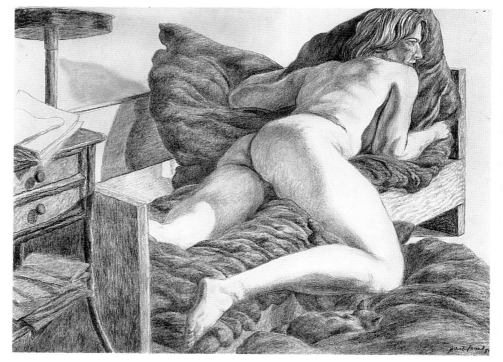

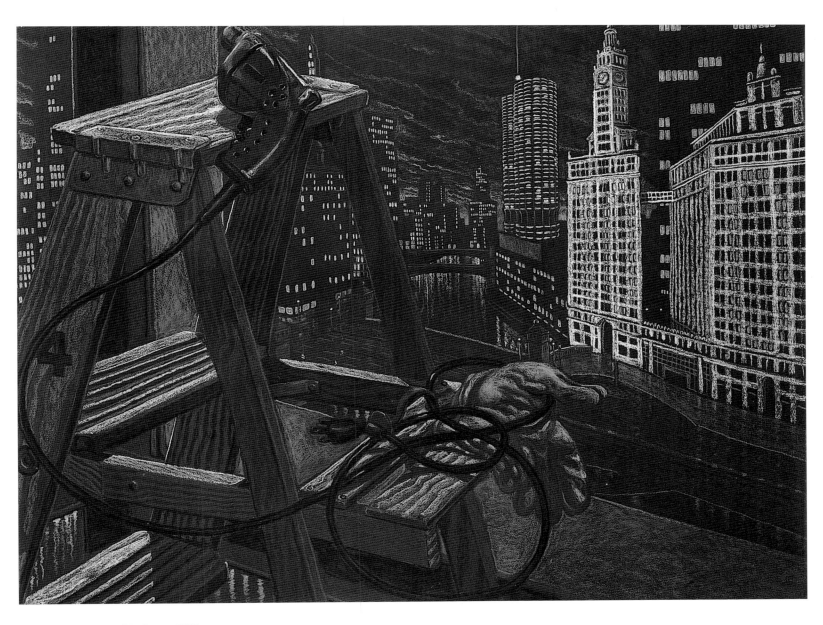

Chicago Skyline, 1979
pastel on paper
30 × 40 in.
The Art Institute of Chicago—Gift of Mr. and Mrs. Martin Gecht

Portrait with Pillows No. 1, 1984–85
pastel on paper
30 × 42 in.
Lee Wesley and Victoria Granacki

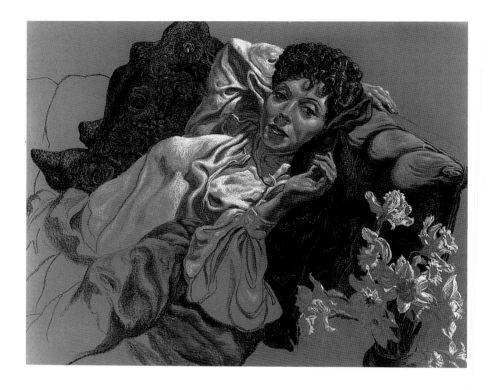

Portrait with Pillows No. 2, 1984–85
pastel on paper
30 × 42 in.
Stuart Handler Family Collection, Evanston, Illinois

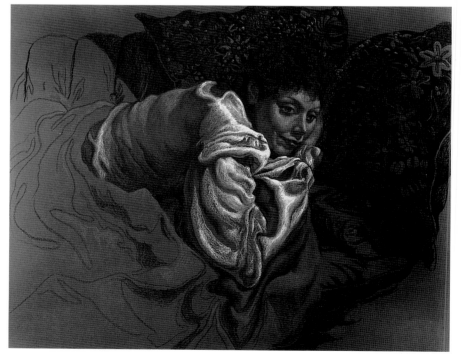

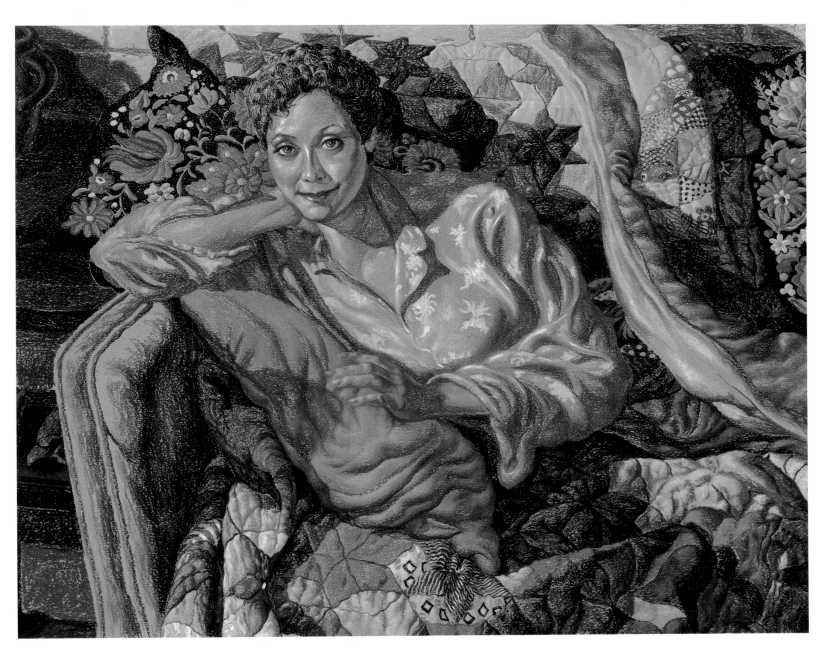

Portrait with Pillows No. 4, 1984–85
pastel on paper
30 × 42 in.
The Crispo Collection, New York

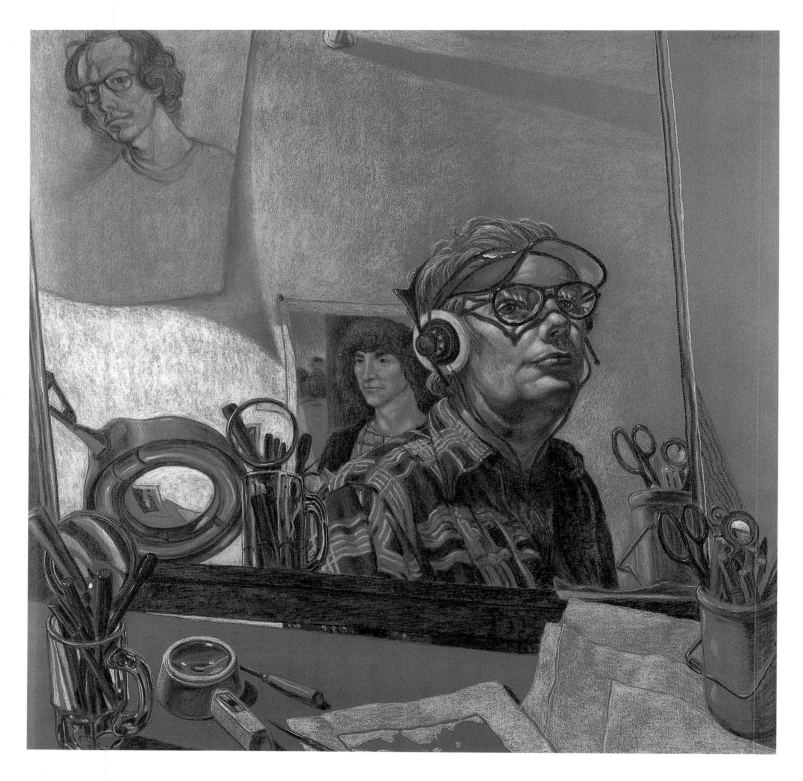

Self-Portrait with Lenses, 1980
pastel on brown paper
48 × 48 in.
Reva and David Logan
Foundation

Portrait with Self-Portrait, 1985
pastel on paper
40 × 32 in.
Smith College Museum of
Art—Gift of Rita Fraad in
memory of her husband
Daniel Fraad

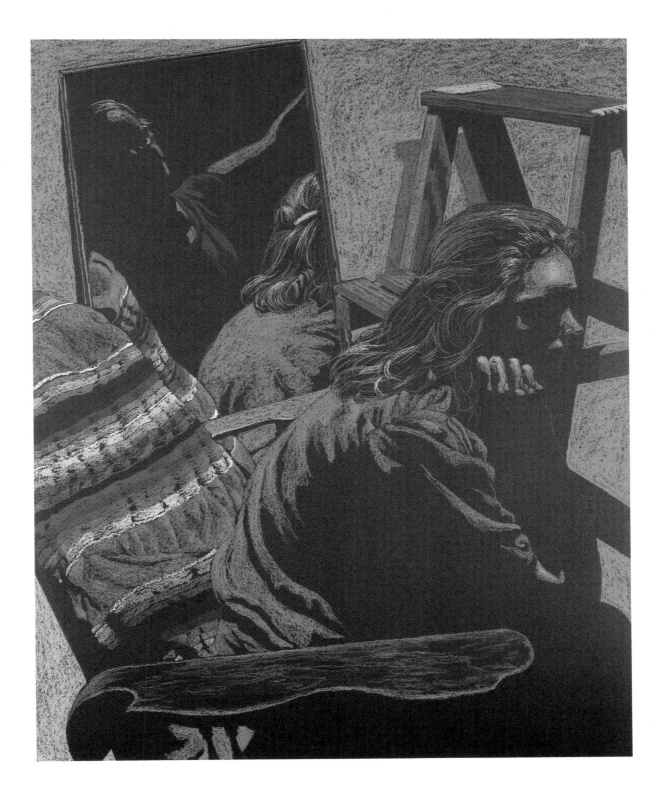

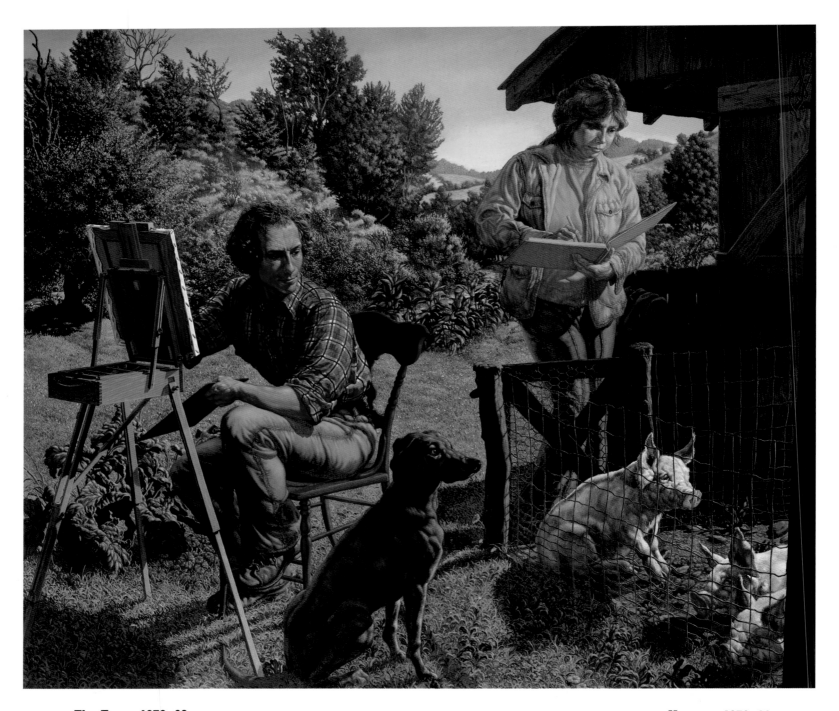

The Farm, 1979–80
oil on canvas
84 × 96 in.
Bayly Art Museum of the University of Virginia,
Charlottesville

Harvest, 1979–80
oil on canvas
96 × 96 in.
G.U.C. Collection

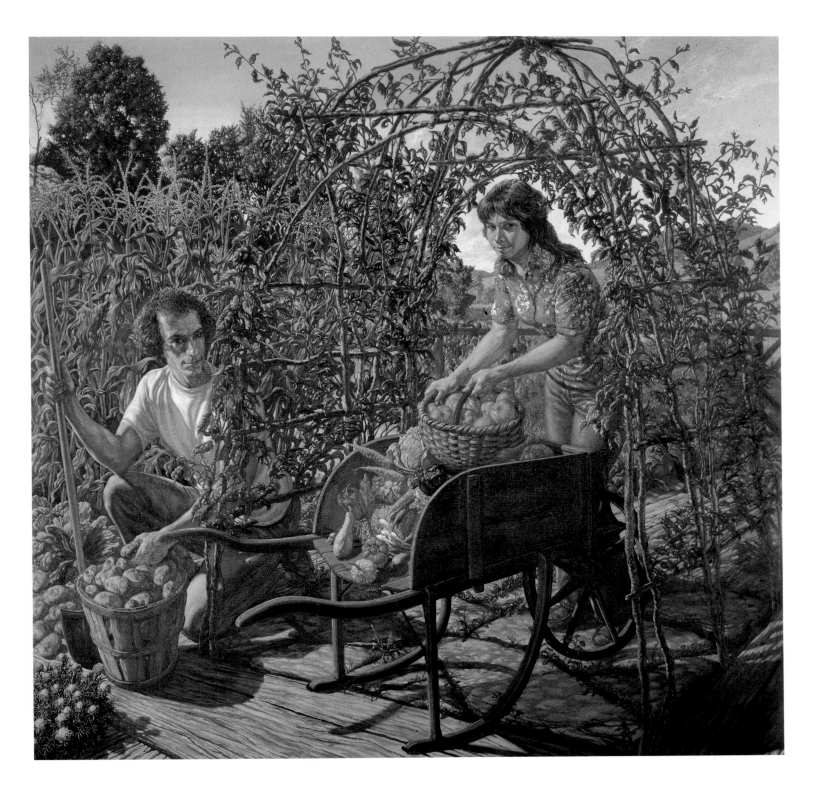

Landscape with Barn and Trees, 1978
pen and ink wash on paper
18 × 21½ in.
Brooke and Carolyn Alexander, New York

The Dark Pool, 1980
pastel on gray paper
48 × 60 in.
Alice Adam, Chicago

Landscape, 1979
pastel on paper
20 × 25⅞ in.
Galerie Claude Bernard, Paris

Downstream (View from the Studio), 1983–84
pastel on paper
32 × 40 in.
Glenn C. Janss Collection

Untitled, 1979–80
pastel on paper
48 × 48 in.
Private collection

Collecting Kindling (View from Epano), 1985
pastel on gray paper
$31\frac{17}{32} \times 38$ in.
Gibbs Family Collection

BIBLIOGRAPHY

BOOKS

Arnason, H. H. *History of Modern Art, 3rd Edition*. New York: Prentice-Hall/Harry N. Abrams, 1986, pp. 614, 983. Illus.

Art in Architecture Program. Washington, D.C. U.S. General Services Administration, 1979, unpaged. Illus.

Arthur, John. *Realist Drawings & Watercolors: Contemporary American Works on Paper*. Boston: New York Graphic Society, 1980, pp. 25–27, 35. Illus.

_____. *Realists at Work: Studio Interviews and Working Methods of 10 Leading Contemporary Painters*. New York: Watson-Guptill, 1983, pp. 10–23, 160. Illus.

_____. *Spirit of Place: Contemporary Landscape Painting and the American Tradition*. Boston: Bulfinch Press/Little, Brown, 1989, pp. 106–107, 109. Illus.

Ashton, Dore. *American Art Since 1945*. New York: Oxford University Press, 1982, pp. 111, 169, 171. Illus.

Battcock, Gregory, ed. *Super Realism: A Critical Anthology*. New York: E. P. Dutton, 1973, pp. 4, 14, 16, 37, 115, 117, 124. Illus.

Brandt, Frederick R. *Late 20th Century Art: Selections from the Sydney and Frances Lewis Collection in the Virginia Museum of Fine Arts*. Seattle and London: University of Washington Press, pp. 14–15. Illus.

Cole, Bruce, and Adelheid Gealt. *Art of the Western World: From Ancient Greece to Post-Modernism*. New York: Summit Books, 1989, pp. 328, 329. Illus.

Current, Richard N., T. Harry Williams, and Frank Friedel. *American History: A Survey, 5th Edition*. New York: Borzoi/Alfred A. Knopf, 1979, opp. p. 817. Illus.

Cummings, Paul. *American Drawings: The 20th Century*. New York: Viking Press, 1976, pp. 190–191, 208. Illus.

_____. *Dictionary of Contemporary American Artists*. New York: St. Martin's Press, 1977, pp. 83–84. Illus.

Doezema, Marianne. *American Realism and the Industrial Age*. Cleveland: Museum of Art, 1980, pp. 132–137. Illus.

Frankenstein, Alfred. *The Reality of Appearance: The Trompe l'Oeil Tradition in American Painting*. Berkeley: University of California Art Museum, 1970.

Goodyear, Frank H., Jr. *Contemporary American Realism Since 1960*. Boston: New York Graphic Society in association with Pennsylvania Academy of the Fine Arts, 1981, pp. 13, 20, 21, 23, 25, 30–31, 40, 54, 59, 64, 73, 75, 84, 86, 90, 95, 98–99, 116–121, 135, 193, 238. Illus.

Haim, Nadine. *The Artist's Palate*. Paris: Flammarion, 1985; New York: Harry N. Abrams, 1988; translated by Erich Wolf, pp. 15–19. Illus.

Hills, Patricia, and Roberta K. Tarbell. *The Figurative Tradition and the Whitney Museum of American Art/Paintings and Sculpture from the Permanent Collection*. Cranbury, N.J.: Associated University Presses, 1980, pp. 141–143. Illus.

Howe, Irving, and Joan Mondale. *Images of Labor*. New York: Pilgrim Press, 1981, pp. 52–53. Illus.

Jencks, Charles. *Post-Modernism, The New Classicism in Art and Architecture*. New York: Rizzoli, 1978, pp. 38, 152, 170.

_____. *What Is Post-Modernism?* London Academy Editions; New York: St. Martin's Press, 1979, p. 28.

Kultermann, Udo. *New Realism*. Greenwich, Conn.: New York Graphic Society, 1972, pp. 24–26. Illus.

Le Clair, Charles. *Color in Contemporary Painting*. New York, Watson-Guptill, 1991, pp. 36, 75, 104, 105, 106, 206–208, 212. Illus.

Strand, Mark, and Robert Hughes. *Art of the Real: Nine American Figurative Painters*. New York: Clarkson N. Potter, 1983, pp. 40–59, 230–231. Illus.

Ward, John L. *American Realist Painting, 1945–1980*. Ann Arbor, Mich.: UMI Research Press, pp. 148, 156–166, 167, 171, 174, 180, 197, 267, 270, 370, 372, 386. Illus.

EXHIBITION CATALOGUES

See exhibition listings under Biography

ARTICLES

Adrian, Dennis. "The Stately Splendor of Jack Beal's 'Danaë II,'" *Panorama—Chicago Daily News*. March 15, 1974. Illus.

Albanese, Mary. "Jack Beal Interview," *Art Workers News*, March 1977, p. 3. Illus.

Allan Frumkin Gallery Newsletter, no. 3, Spring 1977.

"Art Imitates Life: The Revival of Realism," *Newsweek*, June 7, 1982, p. 67. Illus.

"Art in New York: Midtown," *Time*, Nov. 1, 1968.

"Art 1965, The Form It Takes," *Village Voice*, Jan. 7, 1965, p. 1. Illus.

"Artist Plans College Visits," *Spokane Daily Chronicle*, March 11, 1972.

"Artists Set Up Studios in Black Lake Locality," *Tribune-Press* (Gouverneur, N.Y.), April 12, 1967. Illus.

Artner, Alan G. "Exhibition Circuit Offers Three Worthwhile Stops," *Chicago Tribune*, Jan. 15, 1978.

Artnews, March 1973. Illus.

Beal, Jack. "Jack Beal," *Art Now: New York*, 1970, vol. 2, no. 3.

_____. "Forum: Jacob Jordaens, The Nymph Adrastea Milking the Goat Amalthea," *Drawing*, July–Aug. 1984, pp. 33–36.

_____. "Isobel Steele MacKinnon Rupprecht, An Appreciation," in *A Tribute to Isobel MacKinnon*, School of the Art Institute of Chicago, 1985, unpaged.

_____. "Sight and Sense, Studying Pictorial Composition," *American Artist*, Feb. 1986, pp. 54–61.

_____. "A Letter to Tibor Csemus," *Arts Magazine*, May 1985, pp. 130–131.

_____. "The Schlock of the New," *Newsday*, New York Forum, Jan. 4, 1991. Illus.

"Beal Show Set for January," *Allan Frumkin Gallery Newsletter*, Fall 1979. Ilus.

Beals, Kathie. "New Art Show in Town . . .and It's for Real," *Gannett Weekend Magazine*, Aug. 1, 1980. Illus.

Blake, E. "The Art World," *Manhattan East*, Dec. 16, 1965. Illus.

Boice, Bruce. *Artforum*, May 1973.

Bonesteel, Michael. "Married Artists Are Their Own Best Fans and Severest Critics," *Wisconsin State Journal*, Oct. 15, 1977, sec. 1, p. 15. Illus.

Bourdon, David. "Art," *Village Voice*, April 28, 1975.

_____. "Aesthetics Bow to American Labor," *Village Voice*, Jan. 10, 1977, p. 75, Illus.

Brown, Thomas A. "Black Lake Artists Find Freedom and Inspiration in the North Country," *Ogdensburg Journal*, April 9, 1967. Illus.

Bruni, Frank. "Painter's Vision Is Doc's Masterpiece," *New York Post*, June 16, 1988, p. 14. Illus.

Canaday, John. *New York Times*, April 8, 1967.

_____. "Win, Draw, or Lose at Chicago's All American Show," *New York Times*, June 25, 1972.

Carter, Betsy. "The Labor Department Mural: A Complicated Voyage," *Artnews*, May 1977, pp. 40–41.

Citron, Cynthia. "Jack Beal," *Spectrum*, Jan. 24, 1974. Illus.

Colby, Joy Hakanson. "Realism Flirts with Surreal Styles in American Art," *Detroit News*, Oct. 8, 1978, p. 4F. Illus.

"The Collections," *Toledo Museum of Fine Art, Annual Report*, 1979, p. 89. Illus.

Connor, Harriet J. "Chronoscope," *Spokane Daily Chronicle*, March 15, 1972, p. 19. Illus.

Cooper, James F. "Art Galleries," *New York City Tribune*, Feb. 5, 1988. Illus.

Cottingham, Jane. "For Real: Painting by Jack Beal," *American Artist*, Nov. 1980, pp. 58–63. Illus.

Cummings, Paul. "Interview: Jack Beal Talks with Paul Cummings," *Drawing*, March–April 1981, pp. 128–131.

Danikian, Carol Le Brun. "What Art Collectors Buy," *Christian Science Monitor*, Jan. 23, 1979, p. 14.

"Disneyland by Night," *Film Comment*, Jan–Feb. 1977, p. 11.

"Display of Small Paintings Offered at Albrecht Gallery," *St. Louis News-Press*, Feb. 9, 1969, p. 8-C. Illus.

Donker, Peter P. "School of Realism Runs to Top Class at the Danforth," *Worcester Sunday Telegram*, May 25, 1980, pp. 20A, 22A. Illus.

Donohoe, Victoria. "In a Mural, an Artist Can Make a Statement in a Big Way," *Philadelphia Inquirer*, Jan. 3, 1981.

_____. "Academy's Show of Realists Is Big but Sadly Unfocused," *Philadelphia Inquirer*, Sept. 20, 1981, p. 22F.

Eliasoph, Philip. "Silvermine Guild's Exhibit Offers Food for Thought," *Advocate and Greenwich Time*, June 7, 1987, p. D5.

Ellenzweig, Allen. "Jack Beal," *Arts Magazine*, Sept. 1975, pp. 6–7.

H.F. "Back to Reality," *New Republic*, 1977, p. 42.

N.F. "Jack Beal," *Arts Magazine*, Nov. 1968. Illus.

"The Fantasy of Reality," *Time*, April 11, 1969. Illus.

Forgey, Benjamin. "Jack Beal's History of American Labor," *Artnews*, April 1977, p. 38.

Frank, Peter. "New York Art Notes: Jack Beal," *Columbia Owl*, Oct. 30. 1986, p. 6. Illus.

Frankenstein, Alfred. "'Untitled' with a Touch of Protest," *This World*, Nov. 17, 1968, p. 49. Illus.

Friend, Miriam. "Realism at Squibb," *Princeton Packet*, Jan. 15, 1975, p. 13, Illus.

French-Frazier, Nina. "New York: Jack Beal," *Art International*, March–April 1980.

"From the Sweaty to the Surreal," *Life*, Oct. 1980, p. 81. Illus.

Garret, Bob. "Hyper-Realist Jack Beal at BU," *Boston Herald Traveler*, Nov. 3, 1973.

Genauer, Emily. "Art and the Artist," *New York Post*, Feb. 17, 1973, p. 34; Magazine, p. 14.

Glueck, Grace. "Madison Avenue: Uptown, It's Couples," *New York Times*, Feb. 17, 1984, pp. C1, C14. Illus.

Goldberger, Paul. "A Meeting of Artistic Minds," *New York Times*, Sunday Magazine, March 1, 1981, pp. 70–73, 80. Illus.

Green, Roger. "Things Have Changed in New Orleans," *Artnews*, Feb. 1982, pp. 110–113.

_____. "Vision: The World of Art," *New Orleans Times-Picayune*, March 14, 1982, pp. 1–9.

Grimes, Nancy. "Facts of Life," *Artnews*, Dec. 1988, pp. 118–122. Illus.

Gruen, John. "Passion and Poetry," *New York*, Nov. 4, 1968, p. 19. Illus.

Guilbert, Gladys. "Jack Beal Scheduled as Guest Artist," *Spokane Daily Chronicle*, March 1972. Illus.

Guillard, Betty. "Rock Hudson's Coming to the Crescent City with 'Murder' in Mind," *New Orleans Times-Picayune*, March 12, 1982, sec. P, p. 6.

G.H. "Jack Beal," *Artnews*, March 1972.

Haller, Emanuel. "Realism in Forefront at Mortimer Gallery," *Courier-News* (N.J.), Jan. 17, 1988.

Harnett, Lila. "Virtue vs. Vice," *Cue*, Feb. 18–March 3, 1978. Illus.

"Harold Joachim 1909–1983," *Drawing*, March–April 1984, p. 131. Illus.

Henry, Gerrit. "The Real Thing," *Art International*, Summer 1972, pp. 87–88.

_____. "Jack Beal: A Commitment to Realism," *Artnews*, Dec. 1984, pp. 94–100. Illus.

Higgins, Tim. "Beauty in the Feast," *Morning Call*, Sept. 24, 1986, pp. D1, D16.

Hughes, Robert. "Realism as Corn God," *Time*, Jan. 31, 1972, pp. 50–55.

_____. "Lost Among the Figures," *Time*, May 31, 1982, pp. 64–67. Illus.

"Jack Beal," *New York Times*, Jan. 16, 1965.

"Jack Beal," *New York Herald Tribune*, Dec. 4, 1965.

"Jack Beal," *Arts Magazine*, Sept. 1975. Illus.

"Jack Beal at Work on Labor Building Murals," *Allan Frumkin Gallery Newsletter*, Spring 1976.

"Jack Beal," *Village Voice*, Feb. 20, 1978.

Johnson, Charles. "San Francisco Show: A Bitter 'Memorial' to War," *Sacramento Bee*, Nov. 17, 1968.

"Kinds of Realism," *Allan Frumkin Gallery Newsletter*, Winter 1979, Special issue.

Kittredge, Carola. "Gardens: A Living Palette: Sondra and Jack Beal in New York State." *Architectural Digest*, June 1988, pp. 164–169. Illus.

Kohen, Helen L. "Still-Life Paintings That Will Take Your Breath Away," *Miami Herald*, p. 2L.

Kramer, Hilton. "Jack Beal Show Opens," *New York Times*, Dec. 4, 1965.

_____. "Jack Beal," *New York Times*, Oct. 12, 1968.

_____. "Jack Beal," *New York Times*, Feb. 12, 1972.

_____. "Art," *New York Times*, April 26, 1975.

_____. "A Muralist Celebrates Labor," *New York Times*, Jan. 7, 1977, pp. C1, C15. Illus.

_____. "Art: Moral Vision in Mannered Style," *New York Times*, Feb. 17, 1978, p. 21. Illus.

_____. "Jack Beal's Unabashed Social Realism," *New York Times*, Feb. 10, 1980, pp. 29, 31. Illus.

_____. "An Antidote to the Postmodern Blues: 'Realism Today' at the National Acadmey," *New York Observer*, Dec. 27, 1988.

Kuspit, Donald B. "What's Real in Realism," *Art in America*, Sept. 1981, pp. 83–94. Illus.

Lerman, Ora. "Contemporary Vanitas," *Arts Magazine*, March 1988, pp. 60–63. Illus.

"The Lonely Look of American Realism," *Life*, Oct. 1980, pp. 74–82. Illus.

Lubell, Ellen. "Jack Beal," *Soho Weekly News*, Feb. 23, 1978.

Marsi, Rick. "Artist Jack Beal: His Brushes Catch the Beauty of Life," *Press & Sun Bulletin* (Binghamton, N.Y.), Nov. 15, 1987, pp. 1C, 7C. Illus.

Massengale, Jean. "Food Glorious Food," *Darien News-Review*, May 28, 1987.

McGill, Douglas. "Philanthropic Society," *New York Times*, Nov. 16, 1986.

Mendle, Bob. "A Double Treat That Is Not Effete," *California Aggie*, Nov. 12, 1968, p. 2. Illus.

Merritt, Robert. "Art Has Become Near-Sighted," *Richmond Times-Dispatch*, Oct. 24, 1980. Illus.

_____. "Jack Beal," *Richmond Times-Dispatch*, Oct. 25, 1980. Illus.

Mertens, Richard. "For Jack Beal, Art Means Facing Up to Responsibilities," *Concord Monitor*, Sept. 20, 1984, p. 5. Illus.

Merz, Beverly. "The Cover," *Journal of the American Medical Association*, Dec. 4, 1987, p. 3077. Cover Illus.

Middlebury College Magazine, Autumn 1989, p. 9. Illus.

Mullen, Rachel. "New York Realists Gather at Mortimer Gallery," *Bernardsville News* (N. J.), Jan. 28, 1988. Illus.

Murray, Mary. "A *New* New Realism?" *An Art Journal: Dialogue*, Jan.–Feb. 1987, p. 37. Illus.

"Narrative Painting to Be Shown in June," *Allan Frumkin Gallery Newsletter*, Spring 1981. Illus.

New Criterion, June 1984.

Nichols, Jessie. "Oneonta-Area Artist Paints 'History of American Labor,'" *Daily Star* (Oneonta, N.Y.), Dec. 29, 1975, p. 5. Illus.

————. "Jack Beal Paints from His Own Life," *Daily Star*, Dec. 30, 1975, p. 5. Illus.

————. "Jack Beal's Mural Depicts Allegories," *Daily Star*, Dec. 31, 1975.

North, Charles. "Jack Beal at Frumkin," *Art in America*, Sept.–Oct. 1975, pp. 99–100.

Olson, Roberta J.M. "When Jack Is Trump: Beal's Murals," *Soho Weekly News*, Jan. 20, 1977. Illus.

R.P. "Reviews and Previews: Jack Beal," *Artnews*, Nov. 1968.

Perlmutter, Elizabeth Frank. "New Editions," *Artnews*, Sept. 1974. Illus.

Perreault, John. "Art: Long Live Earth!," *Village Voice*, Oct. 17, 1968.

————. "Art," *Village Voice*, Feb. 17, 1972.

————. "Caught in a Shower of Gold," *Village Voice*, Feb. 15, 1973, pp. 25–26, 30.

Phelan, Sean M. "'Nothing Is More Important than' Babies and Breakfast . . . Jack Beal in Conversation," *Weekly Pennysaver* (Binghamton, N.Y.), cover, p. 3. Illus.

Pieszak, Devonna. "Jack Beal," *New Art Examiner*, April 1978.

————. "Interview with Jack Beal," *New Art Examiner*, Nov. 1979, pp. 3, 6–7.

Pincus-Witten, Robert. "Jack Beal," *Artforum*, 1968, p. 56. Illus.

Portfolio, Sept.–Oct. 1981, p. 86. Illus.

"Public Commissions: A Variety of Approaches," *Allan Frumkin Gallery Newsletter*, Spring 1980.

"Q & A: Artist, Champion of Realism, Jack Beal," *New Hampshire Times*, Sept. 29, 1984, p. 14. Illus.

Raynor, Vivien. "The Brightly Realistic Perspective of Jack Beal," *New York Times*, 1980.

"Revival of Realism," *Newsweek*, June 7, 1982, pp. 64–67. Illus.

Richardson, Denise. "Plain Dealing: Artist Finds a Wealth of Beauty in Everyday Life," *Daily Star* (Oneonta, N.Y.), Nov. 18, 1987. Illus.

Russell, John. "70's Art in Public Places from Anchorage to Atlanta," *New York Times*, July 6, 1980.

————. "Early Works by Jack Beal and Joan Brown," *New York Times*, March 16, 1984.

Schadler, Elaine. "Food for Thought: Art Museum Offers Bountiful Feast," *Globe-Times*, Sept. 17, 1986, pp. D1–D2. Illus.

Schjeldahl, Peter. "A Shot in the Arm for Realism," *New York Times*, Feb. 18, 1973. Illus.

Schulze, Franz. "Figuratively Speaking," *Panorama-Chicago Daily News*, April 5, 1969.

————. "Hanging Around at the Art Institute," *Panorama-Chicago Daily News*, Feb. 18, 1978, p. 14. Illus.

Schwartz, Ellen. "Jack Beal," *Artnews*, April 1978, p. 148.

Schwartz, Sanford. "New York Letter," *Art International*, May 1973, p. 41. Illus.

Seldis, Henry J. "A Broad but Rare Contemporary View," *Los Angeles Times*, Nov. 1968, p. 56.

Silver, Laura. "Who's Who in Realism: Readers and Experts Choose; A Pictorial Essay," *U.S. Art*, July–Aug. 1989, pp. 48–55. Illus.

Smith, Roberta Pancoast. *Arts Magazine*, April 1973.

Smith, Scott. "A Conversation with Jack Beal," *Q. A Journal of Art*, July 1988, pp. 10–12. Illus.

Stevens, Mark. "Revival of Realism," *Newsweek*, June 7, 1982, pp. 64–70. Illus.

Tallmer, Jerry. "The Big Tomatoes Are Real," *New York Post*, Jan. 19, 1980. Illus.

Taylor, Robert. "Jack Beal Stirs Up the Art World," *Boston Globe*, Jan. 23, 1974, p. 22. Illus.

————. "Jack Beal Blends Opposites at BU," *Boston Sunday Globe*, Jan. 27, 1974, p. 98. Illus.

Tully, Judd. "The Art of Labor," *Washington Post-Potomac Magazine*, March 20, 1977, p. 3. Illus.

"Unphotography," *Time*, April 11, 1969, pp. 80–81.

Van Gelder, Pat. "Representing Realist Artists," *American Artist*, May 1987, pp. 64–69, 91. Illus.

Vreede, Caroline. "Everyone Can Appreciate Beal's Roberson Exhibit," *Press & Sun Bulletin*, Nov. 20, 1987, p. 3D. Illus.

Watkins, Eileen. "Gladstone Exhibit Showcases 'Realism' with Interesting Results in Various Forms," *Sunday Star Ledger* (Newark, N.J.), Jan. 24, 1988, p. 14, sec. 4.

Weaver, Gay M. "Novel Show Features Drawing," *Palo Alto Times*, Feb. 25, 1972, p. 11.

Wolff, Theodore F. "Drawings from the Famous and the Promising," *Christian Science Monitor*, Jan. 20, 1988.

Zimmer, William. "Art: Self-Portraits at Claude Bernard," *New York Times*, Sept. 19, 1986.

BIOGRAPHY

BORN

1931
Richmond, Virginia

LIVES

New York City and near Oneonta, New York

EDUCATION

1950–53
College of William and Mary, Norfolk Division

1953–56
School of the Art Institute of Chicago

1955–56
University of Chicago

Jack Beal with *The History of Labor:
18th Century—"Settlement"*

SOLO EXHIBITIONS

1965
Allan Frumkin Gallery, New York (two exhibitions)

1966
Allan Frumkin Gallery, New York
Allan Frumkin Gallery, Chicago

1967
Allan Frumkin Gallery, New York

1968
Allan Frumkin Gallery, New York

1969
Allan Frumkin Gallery, Chicago

1970
Allan Frumkin Gallery, New York

1972
Allan Frumkin Gallery, New York
Miami-Dade Community College, Florida

1973
Allan Frumkin Gallery, New York
Galerie Claude Bernard, Paris (cat.)*

1973–74
Retrospective exhibition, Virginia Museum of Fine Arts,
Richmond; University Gallery, Boston University; Museum
of Contemporary Art, Chicago (cat.)

1974
Allan Frumkin Gallery, Chicago

1975
Allan Frumkin Gallery, New York (cat.)

1977
"Jack Beal: Prints and Related Drawings," organized by the
Madison Art Center, Wisconsin; traveled to University
Gallery, Boston University; Art Institute of Chicago (cat.)

1978
Allan Frumkin Gallery, New York

1980
Allan Frumkin Gallery, New York
Reynolds/Minor Gallery, Richmond, Virginia

1981
Galerie Claude Bernard, Paris
"Jack Beal/Sondra Freckleton: Pastels, Watercolors and
Prints," Alice Simsar Gallery, Ann Arbor, Michigan

1984
"Jack Beal/Joan Brown: The Early Sixties," Allan Frumkin
Gallery, New York (cat.)

1985
Allan Frumkin Gallery, New York (Drawing Gallery)

1987–88
"Jack Beal: Images on Paper," Roberson Center for the Arts
and Sciences, Binghamton, New York (cat.)

1988
Frumkin/Adams Gallery, New York

1990
Atlantic Center for the Arts, Florida
Halsey Gallery, College of Charleston, South Carolina;
Gian-Carlo Menotti Artist-in-Residence at the Spoleto Festival

1992
Muscarelle Museum of Art, College of William and Mary,
Virginia

*(cat.) indicates exhibition was accompanied by catalogue.

SELECTED GROUP EXHIBITIONS

1956
"Momentum 1956," Chicago (cat.)

1965
"Nebraska Art Association's LXXIIII Annual Exhibition,"
Sheldon Memorial Art Galleries, University of Nebraska,
Lincoln (cat.)
J. B. Speed Museum, Louisville, Kentucky
"68th Annual Exhibition," Art Institute of Chicago (cat.)
"Young America 1965," Whitney Museum of American Art,
New York (cat.)
"Modern Realism and Surrealism," organized by American
Federation of the Arts, New York
"The Figure International," organized by American
Federation of the Arts, New York
"Recent Still-Life," Art Museum, Rhode Island School of
Design, Providence (cat.)

1966
"Neysa McMein Purchase Awards," Whitney Museum of
American Art, New York
"Contemporary Art, U.S.A.," Norfolk Museum, Virginia
"The Media of Art Now," Art Museum, University of
Kentucky, Louisville
Group Show, Galerie Claude Bernard, Paris

1967
"Environment," Dintenfass Gallery, New York
"Contemporary American Drawings," Art Museum,
University of Colorado
"The Nude Now," Allan Frumkin Gallery, New York
"Recent Figurative Art," Bennington College, Vermont
"Realism Now," Vassar College, Poughkeepsie, New York
(cat.)
Whitney Annual, Whitney Museum of American Art, New
York (cat.)

1968
"United: 1968," San Francisco Museum of Modern Art (cat.)

1968–69
Group Show, San Francisco Museum of Art

1969
"Directions 2: Aspects of New Realism," Milwaukee Art
Center; Museum of Contemporary Art, Houston; Akron Art
Institute, Ohio (cat.)
"Contemporary American Painting and Sculpture," Krannert
Art Museum, Champaign, Illinois (cat.)
Whitney Annual, Whitney Museum of American Art, New
York (cat.)
"Report on the Sixties," Denver Art Museum

1970
"Four Views," New Jersey State Museum, Trenton (cat.)
"National Drawing Exhibition," San Francisco Museum of
Modern Art (cat.)
"Seventeenth National Print Exhibition," Brooklyn Museum,
New York (cat.)

"22 Realists," Whitney Museum of American Art, New York
(cat.)
"Works on Paper," Virginia Museum, Richmond

1971
"Drawing by Representational Painters," Art Center
Gallery, Menomonie, Wisconsin (cat.)
"American Exhibition of Contemporary Painting and
Sculpture," National Academy and Institute of Arts and
Letters, New York (cat.)
"American Drawing, 1971," Iowa State University, Ames;
MacNider Museum, Mason City (cat.)
"New Realism," State University of New York, Potsdam;
Delaware Art Museum, Wilmington (cat.)
"Phases of New Realism," Lowe Art Museum, Coral Gables,
Florida
"Two Directions in American Painting," Purdue University,
West Lafayette, Indiana (cat.)

1972
"The American Landscape/1972," Boston University School
of Fine and Applied Arts Gallery, Boston (cat.)
"Christmas 1972," Museum of Modern Art, New York (cat.)
"Painting and Sculpture Today: 1972," Indianapolis Museum
of Art (cat.)
"Drawings by Living American Artists," International
Exhibitions Foundation, Washington, D.C.
"70th American Exhibition," Art Institute of Chicago (cat.)
"Realist Revival," organized by American Federation of the
Arts, New York

1973
"American Drawings 1963–1973," Whitney Museum of
American Art, New York (cat.)
"Drawings," Galerie Smith-Andersen, Palo Alto, California
(cat.)
"American Realism: Post Pop," Art Gallery, Oakland
University, Rochester, Michigan
"Drawings by Seven American Realists," Harcus-Krakow
Gallery, Boston
"Hand-Colored Prints," Brooke Alexander Gallery, New
York (cat.)

1973–74
"The Richard Brown Baker Collection," San Francisco
Museum of Modern Art; Institute of Contemporary Art,
University of Pennsylvania, Philadelphia (cat.)

1974
"Aspects of the Figure," Cleveland Museum of Art (cat.)
"Contemporary American Paintings from the Lewis
Collection," Delaware Art Museum, Wilmington (cat.)
"Living American Artists and the Figure," Pennsylvania
State University Museum of Art, College Park
"New Images: Figuration in American Painting," Queens
County Museum, New York

1975

"American Realists: Watercolors and Drawings," Meisel Gallery, New York (cat.)

"Davidson National Print and Drawing Competition," Stowe Gallery, Davidson College, Davidson, North Carolina (cat.)

"Drawings: Techniques and Types," William Benton Museum of Art, University of Connecticut, Storrs (cat.)

"Portrait Painting, 1970–1975," Allan Frumkin Gallery, New York (cat.)

"Candid Painting: American Genre, 1950–1975," DeCordova Museum, Lincoln, Massachusetts (cat.)

"Selected Works from the Private Collection of Arnold and Mona Root," Miami-Dade Community College, Miami, Florida (cat.)

1976

"The Figure in Drawing Now," Bennington College, Vermont

"Visions: Painting and Sculpture: Distinguished Alumni 1945 to the Present," School of the Art Institute of Chicago (cat.)

"Washington Print Club: Member's Show," Washington, D.C. (cat.)

1976–77

"30 Years of American Printmaking," Brooklyn Museum

"Artists' Choice, Figurative Art in New York," Green Mountain Gallery, Bowery Gallery, Prince Street Gallery, First Street Gallery, and SoHo Center for Visual Artists, New York (cat.)

1976–78

"America '76," organized by the U.S. Department of the Interior; traveled to Corcoran Gallery, Washington, D.C.; Wadsworth Atheneum, Hartford, Connecticut; Fogg Museum, Harvard University, Cambridge; Institute of Contemporary Art, Boston; Brooklyn Museum (cat.)

1977

"American Drawing: 1927–1977," Minnesota Museum of Art, St. Paul (cat.)

"Collectors Collect Contemporary: A Selection from Boston's Collections," Institute of Contemporary Art, Boston (cat.)

"The Book as Art," Fendrick Gallery, Washington, D.C. (cat.)

1978

"An Invitational Drawing Show," DePauw University Art Center, Greencastle, Indiana (cat.)

"Graphica Creativa," Alvar Aalto Museum, Museum of Central Finland, Jyväskylä (cat.)

"Return to Realism: Four from the Allan Frumkin Gallery," Meadow Brook Art Gallery, Oakland University, Rochester, Michigan (cat.)

1979

"American Portraits of the Sixties & Seventies," Aspen Center for the Visual Arts, Colorado (cat.)

"Artists' Choice Museum Prospectus and Benefit Exhibition," Artists' Choice Museum, New York (cat.)

"The Pastel in America," Odyssia Gallery, New York; Grand Rapids Art Museum, Michigan

"Works on Paper," Allan Frumkin Gallery, New York

"The Big Still-Life," Allan Frumkin Gallery, New York; University of Virginia, Charlottesville; Art Gallery, Boston University (cat.)

"The Opposite Sex: A Realist Viewpoint," Art Gallery, University of Missouri, Kansas City

"American Tradition and the Image of Post-Modern Man in Contemporary Painting, Drawing and Sculpture," University of Virginia Art Museum, Charlottesville

"Seven on the Figure," Pennsylvania Academy of the Fine Arts, Philadelphia (cat.)

"Figurative/Realist Art," benefit exhibition for Artists' Choice Museum in New York: Allan Frumkin; Terry Dintenfass; Fischbach; Kornblee; Brooke Alexander; and Marlborough galleries, New York (cat.)

1979–80

"The 1970s: New American Painting Curated by The New Museum of Contemporary Art," New Museum, New York (cat.)

"Pictură novă în America deceniului al optulea," exhibition circulated in Europe by New Museum of Contemporary Art, New York (cat.)

"100 Artists 100 Years: Centennial Exhibition," Art Institute of Chicago (cat.)

"Four Realist Artists Selected by Jack Beal and Alex Katz," Dorothy Rosenthal Gallery, Chicago

1980

"Aspects of the '70s: Directions in Realism," Danforth Museum, Framingham, Massachusetts (cat.)

"Brooke Alexander: A Decade of Print Publishing, 1968–77," Delaware Art Museum, Wilmington

"Realism and Metaphor," USF Art Galleries, College of Fine Arts, University of South Florida, Tampa (cat.)

"American Realism of the 20th Century," Morris Museum of Arts and Sciences, Morristown, New Jersey

"Late 20th Century Art from the Sydney and Frances Lewis Foundation," Madison Art Center, Wisconsin (cat.)

"Realism/Photorealism," Philbrook Art Center, Tulsa, Oklahoma (cat.)

"American Figure Painting 1950–80," Chrysler Museum, Norfolk, Virginia

"The Figurative Tradition," Whitney Museum of American Art, New York (cat.)

1980–81

"Across the Nation," National Collection of Fine Arts, Smithsonian Institution, Washington, D.C.; Hunter Museum of Art, Chattanooga, Tennessee (cat.)

"American Drawings in Black and White," Brooklyn Museum

"American Realism and the Industrial Age," Cleveland Museum of Art; Kenneth C. Beck Center for the Cultural Arts, Lakewood, Ohio; Columbus Museum of Art (cat.)

1981

"The American Landscape: New Developments," Whitney Museum of American Art, Greenwich, Connecticut (cat.)

"A Feast for the Eyes," Heckscher Museum, Huntington, New York (cat.)
"45th Annual Midyear Show," Butler Institute of American Art, Youngstown, Ohio (cat.)
"Masters of American Realism," Fort Wayne Museum of Art, Indiana (cat.)
"New Dimensions in Drawing," Aldrich Museum of Contemporary Art, Ridgefield, Connecticut (cat.)
"Realist Drawings," Allan Frumkin Gallery, New York (cat.)

1981–82
"Inside Out: The Self Beyond Likeness," Newport Harbor Art Museum, California; Portland Art Museum, Oregon; Joslyn Art Museum, Omaha, Nebraska (cat.)
"Real/Really Real/Super Real," San Antonio Museum of Art; Indianapolis Museum of Art; Tucson Museum of Art, Arizona; Museum of Art, Carnegie Institute, Pittsburgh (cat.)
"Contemporary American Realism Since 1960," Pennsylvania Academy of the Fine Arts, Philadelphia; Virginia Museum of Fine Arts, Richmond; Oakland Museum, California; Gulbenkian Foundation, Lisbon; Sala de Esposiciones, Madrid; Kunsthalle, Nuremberg (cat.)

1981–83
"Still-Life Today," circulated by the Gallery Association of New York State to Michael C. Rockefeller Gallery, State University College at Fredonia; Tyler Art Gallery, State University at Oswego; Root Art Center, Hamilton College, Clinton; College of St. Rose, Albany; Skidmore College, Saratoga Springs; Federal Reserve Bank of New York; Hudson River Museum, Yonkers; Prendergast Library Art Gallery, Jamestown; Hyde Collection, Glens Falls; Federal Reserve Board, Washington, D.C. (cat.)

1982
"An Appreciation of Realism," Munson-Williams-Proctor Institute, Utica, New York (cat.)
"Contemporary Realism," Brainerd Art Gallery, State University College of Arts and Sciences, Potsdam, New York; Plaza Gallery, State University Plaza, Albany, New York (cat.)
"The Human Figure in Contemporary Art," Contemporary Arts Center, New Orleans (cat.)
"Focus on the Figure: Twenty Years," Whitney Museum of American Art, New York (cat.)
"Selections from the Dennis Adrian Collection," Museum of Contemporary Art, Chicago (cat.)

1983
"American Still-Life: 1945–83," Contemporary Art Museum, Houston (cat.)
"Jones Road Print Shop and Stable: 1971–81: A Catalogue Raisonné," Madison Art Center, Wisconsin (cat.)
"Perspectives on Contemporary American Realism: Works of Art on Paper from the Collection of Jalane and Richard Davidson," Pennsylvania Academy of the Fine Arts, Philadelphia; Art Institute of Chicago (cat.)
"American Realism 1930's/1980's: A Comparative Perspective," Summit Art Center, New Jersey (cat.)

"New Portraits: Behind Faces," Dayton Art Institute, Ohio (cat.)
"New York, New Art, Contemporary Paintings from New York Galleries," Delaware Art Museum, Wilmington

1984
"Images and Imagery: Works on Paper," Art Gallery, Pace University, New York
"New Realism: Behind the Scenes, Small Paintings and Preliminary Sketches," College of the Mainland, Texas City, Texas (cat.)
"The Artist's Studio in American Painting," Allentown Art Museum, Pennsylvania (cat.)
"The Folding Image: Screens by Western Artists of the Nineteenth and Twentieth Centuries," National Gallery of Art, Washington, D.C.; Yale University Art Gallery, New Haven (cat.)

1985
"American Realism: The Precise Image," Isetan Museum, Tokyo (cat.)
"Artists Choosing Artists," Artists' Choice Museum, New York
"Drawings," Reynolds/Minor Gallery, Richmond, Virginia
"Pastels," Nohra Haime Gallery, New York
"Fortissimo! Thirty Years from the Richard Brown Baker Collection of Contemporary Art," traveling exhibition organized by Art Museum, Rhode Island School of Design, Providence (cat.)
"American Art Today: Still Life," Art Museum, Florida International University, Miami (cat.)
"Recent American Portraiture," Robert Schoelkopf Gallery, New York

1985–87
"American Realism: Twentieth Century Drawings and Watercolors," traveling exhibition organized by San Francisco Museum of Modern Art (cat.)

1986
"Accurate Depictions? Figurative Realist Paintings," Art Gallery, Bowling Green State University, Ohio (cat.)
"A Feast for the Eyes," Allentown Art Museum, Pennsylvania
"Interiors in Paint," Modern Art Consultants, Inc., New York
"Landscape, Seascape, Cityscape," Contemporary Arts Center, New Orleans

"20th Century American Drawings: The Figure in Context,"
International Exhibitions Foundation, Washington, D.C.
(cat.)

1987
"Frivolity and Mortality: The Tradition of Vanitas in
Contemporary Painting," traveling exhibition organized by
Sherry French Gallery, New York

1987–88
"Realism Today: American Drawings from the Rita Rich
Collection," traveling exhibition organized by National
Academy of Design, New York (cat.)

1988
"Realism Now," Judy Youens Gallery, Houston
"Contemporary Interpretive Landscape," Sewall Art
Gallery, Rice University, Houston (cat.)

1989
"A Contemporary Art Auction to Benefit Very Special Arts,"
Christie's, New York (cat.)
"Made in America," Virginia Beach Arts Center, Virginia
"Realist Drawings," Frumkin/Adams Gallery (Drawing
Gallery), New York
"Portraits and Self-Portraits," Alice Simsar Gallery,
Ann Arbor, Michigan
"Small Works by Gallery Artists," Frumkin/Adams Gallery
(Drawing Gallery), New York

1990
"The Figure," Arkansas Art Center, Little Rock (cat.)

1991–92
"The Landscape in Twentieth-Century American Art:
Selections from the Metropolitan Museum of Art": Philbrook
Museum of Art, Tulsa, Oklahoma; Center for the Fine Arts,
Miami, Florida; Joslyn Art Museum, Omaha, Nebraska;
Tampa Museum of Art, Florida; Greenville County Museum
of Art, South Carolina; Madison Art Center, Wisconsin;
Grand Rapids Art Museum, Michigan (cat.)
"American Realism & Figurative Art: 1952–1990": Miyagi
Museum of Art, Sendai, Miyagi; Sogo Museum of Art,
Yokohama; Tokushima Modern Art Museum, Tokushima;
Museum of Modem Art, Shiga; Kochi Prefectural Museum of
Folk Art (cat.)

SELECTED PUBLIC COLLECTIONS

Art Institute of Chicago

Arkansas Art Center, Little Rock

Bayly Art Museum of the University of Virginia, Charlottesville

Christian A. Johnson Memorial Gallery, Middlebury
College, Vermont

Delaware Art Museum, Wilmington

Fine Arts Center/Cheekwood, Nashville, Tennessee

Hirshhorn Museum, Washington, D.C.

Hunter Museum of Art, Chattanooga, Tennessee

Minneapolis Institute of Art, Minnesota

Museum of Modern Art, New York

National Gallery of Art, Washington, D.C.

National Museum of American Art, Washington, D.C.

Neuberger Museum of Art, State University of New York,
Purchase

Philadelphia Museum of Art

The John and Mable Ringling Museum of Art, Sarasota,
Florida

San Francisco Museum of Modern Art

Smith College Museum of Art, Northampton, Massachusetts

Sydney and Frances Lewis School of Law, Washington and
Lee University, Lexington, Virginia

Toledo Art Museum

Valparaiso University, Valparaiso, Indiana

Virginia Museum of the Fine Arts, Richmond

Walker Art Center, Minneapolis, Minnesota

Weatherspoon Art Gallery, University of North Carolina,
Greensboro

Whitney Museum of American Art, New York

INDEX

Page numbers in *italics* refer to illustrations.

PHOTOGRAPH CREDITS